PAiNT!
SEASCAPES
&WATERWAYS

A RotoVision Book. Published and distributed by RotoVision SA, Rue du Bugnon 7, CH-1299 Crans-Près-Céligny, Switzerland. RotoVision SA, Sales, Editorial & Production Office, Sheridan House, 112/116A Western Road, Hove, East Sussex BN3 1DD, UK. Tel: +44 (0)1273 72 72 68. Fax: +44 (0)1273 72 72 69. E-mail: sales@rotovision.com. www.rotovision.com. Copyright © RotoVision SA 2001. All rights reserved. No part of this publication may be reproduced, stored in a retrieval system or transmitted in any form or by any means, electronic, mechanical, photocopying, recording or otherwise, without permission of the copyright holder. 10 9 8 7 6 5 4 3 2 1. ISBN 2-88046-420-X

Design by Paul Kellett. Diagrams by Susan Kellett. Production and separations in Singapore by ProVision Pte. Ltd. Tel: +65 334 7720. Fax: +65 334 7721

PAiNT!
SEASCAPES
&WATERWAYS

BETSY HOSEGOOD

RotoVision

contents

Introduction

Seas, rivers, lakes and waterways have fascinated artists for centuries because of the magical quality of the light which is heightened and transformed by the sparkling reflections off the water. There is something mesmerising, too, about the movement and sound of water as it follows its course down to the sea or ocean or gently swishes against rocks on the shore.

As one of life's necessities water holds great importance in our lives so it is not surprising that it is often given symbolic meaning. Rivers and lakes or water being poured from a jug are often associated with life or our life's blood, while the sea, being so variable, can be compared with our own emotional states. Unconstrained by civility, the sea does not repress emotions – be they calm, joyous or angry – but expresses them freely. Like a small child it can switch from gurgling benevolence to screaming tantrum in a flash, so it is a wonderful motif for the artist to express every kind of emotion, even the darkest.

Although water is a major theme for artists, the genre of seascapes didn't come into being until the end of the 16th century when the idea was introduced by a Dutch painter, Hendrik Vroom. Other forms of water had already made an appearance in the allegorical pictures of the past and continue to be regarded as an important element in the ideal landscape.

Painting water

Capturing water on paper or canvas poses some difficult problems. However, overcoming them is part of the delight of painting. One of the foremost difficulties is that water is transparent and liquid. This isn't so challenging if you are using a thin painting medium such as watercolour or acrylic ink, but if you are using oil or acrylic it can be a problem trying to stop the water looking like concrete. Water is also constantly on the move – even on a canal or mill pond the wind will ruffle its surface while birds, fish and insects create ripples. With the sea things are even more difficult because with each glance the size and position of every wave changes. All you can do is rely on repeating patterns and trust to your experience and judgement to assess what looks right. Monet also recommended constant study: 'in order to really paint the sea you have to see it every day, at every hour and in the same place to come to know the life in this location.'

Painting seas in bad weather requires special dedication. Some artists, such as Peter Misson, are able to paint or sketch from a boat, while others must be content to work from the shore, although even then, with driving wind and rain, this is no easy job. JMW Turner loved to paint from life and for his 'Snow Storm – Steam Boat off a Harbour's Mouth' he said 'I got the sailors to lash me to the mast to observe it; I was lashed for four hours and I did not expect to escape, but I felt bound to record it if I did.' Sadly, after all his efforts this painting was slated by the critics of the time although it is now regarded as one of his great masterpieces.

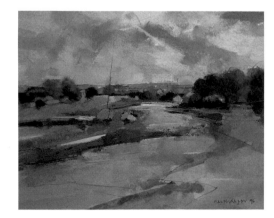

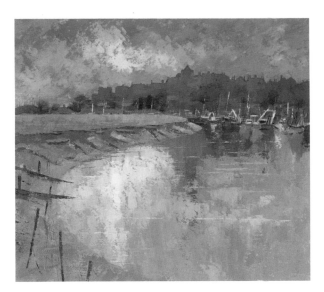

About this book

This book examines the work of a number of artists working in all the main media plus mixed media to show a variety of ways in which this fascinating subject is tackled and to provide an insight into each artist's motivations, inspirations and technique. The work of each artist is examined over eight pages. The first two show the painting as large as possible so you can really see the detail and texture of the paint and they provide written background information. The next two pages concentrate on the composition of the painting, using diagrams to help demonstrate a few main points. This is followed by an examination of the artist's use of colour and then an explanation of his or her technique. As far as possible the artists are allowed to speak for themselves – as if they are taking you on a personal tour of their work. Quotes from the Great Masters provide further inspiration and insight into how artists regard their own work.

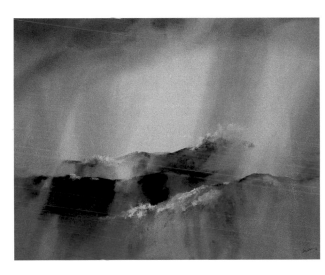

'I want to be always before the sea, or on it and when I die to be buried in a buoy.'
(Claude Monet 1840–1926)

Composition

After providing some background information about each painting or artist this book turns to composition. As with any subject, the first decision which faces the artist is which shape of support to use. The most obvious choice here is a rectangular support which is wider than it is tall. This suits the shape of the sea in particular and provides plenty of space for rendering people on the beach, boats at sea and clouds in the sky. For a canal, on the other hand, a more suitable choice might be a vertical format so that the canal can be viewed straight on. This enables the artist to show more of the water and the items on the banks.

However, it's important not to be complacent about the format and slip into using a particular shape through habit. Always consider whether the scene might be better presented in a different format than the one that first jumps to mind. Your initial instincts may be right, but you may also find that you create a much more striking composition by doing the unexpected. Consider a square format, too, which although difficult to work with can be extremely effective, or think about a very wide format which stresses the panoramic qualities of the scene. Don't be afraid to trim your paper to fit or to stretch your own canvas over a frame or board if necessary.

Your next decision as an artist is what you want as your main focus points and where you are going to place them. Sometimes your focus is obvious – a headland, for example, or a group of boats – but at other times your subject may simply be the sea in a state of turmoil or a city river dancing in the spring sunshine. Whatever it is, aim to show sufficient points of interest to keep your viewers' attention or make sure you create interest in the way you apply the paint. However, don't worry too much about this. If you are inspired by the scene then your viewers are likely to be inspired too, regardless of how strong the focal points are.

Whatever your subject it's important to be flexible about how you place it on the support. Say you wish to paint a cruise liner steaming up the Nile. You could place it in the centre of your support so that it takes up as much of the picture area as possible, but there are other more exciting possibilities. What about placing it off to one side? If there is space in front of the boat you will create a sense of movement as the viewer's eyes follow the course it will take. (This has the added advantage of leading the viewer further into the painting.) Edgar Degas found that cropping off part of the subject accentuated this effect, so you could adopt his technique and crop off the back of the boat to increase the sense of speed. Another option, for a more dramatic look, would be to zoom in on the subject to show just the cabin windows, for example, perhaps reflecting part of the scene to give the viewer a hint of the location. Alternatively you could show the top of the deck with the river view behind it. There are many possibilities so do think all of them through before you begin.

Perhaps your subject is simply the sea and sky. In this case composition is still important. Traditionally the horizon line is placed on one of the horizontal thirds, either on the lower third to give plenty of space to the rendering of the sky, or on the upper third to allow more room to describe the sea. These give very pleasing proportions but they are by no means the only options. Consider, for example, reducing the sky to just a slither of a sixth or less of the picture area. This might work well on a stormy sea where you want to give the waves maximum height. On a sunny day, in contrast, you might decide to show the vast blue of the sky in the majority of the support and squeeze sea and beach into the bottom of the picture. Since blue is such a relaxing colour this will help to produce a restful mood. The key is, as always, that whatever you do you must think it through.

Eye level

Another point to consider before you start work is your eye level, which will be the eye level of the viewer. It is important to be comfortable when you work so you are restricted to an extent, but it might be interesting to view the incoming waves from as near ground level as possible, giving even the smallest waves maximum height. If you want to give the impression of being on a boat, you will obviously need to set eye level at a short height above the sea. Alternatively you could paint from a cliff top looking down for a bird's eye view.

If your subject is a river or canal then more viewpoints may be open to you. Consider finding a handy rock to sit on down on the river bed itself so that you can look right up or down the course of the water, or find a bridge or fallen tree to work from which will also give you a longer vista. Walk a little way up and down in both directions looking carefully to make sure you have found the right spot. This will help you make your compositions more interesting.

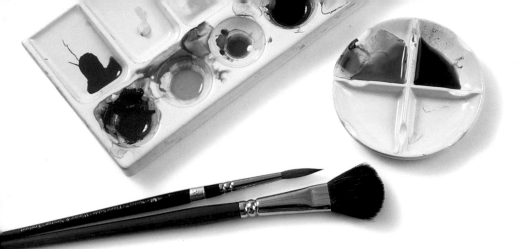

Colour

Mixing the colours for any subject requires some knowledge of colour theory and a good bit of practice. The best thing to do is read a bit about your subject and paint a lot. Have fun with your colours. If you enjoy using them you will continue painting and then you will improve.

Look at the colours that the artists used in this book and see if there are any you particularly like, such as phthalo turquoise or cobalt blue, and if you like them, use them. You don't need many. Monet, who made a lifetime's study of water, used just six: white, cadmium yellow, vermilion, dark madder, cobalt blue and emerald green. He didn't have the vast array of colours to choose from that we have today, but it didn't stop him. Indeed, he didn't think that colour choice was that important, saying 'the real point is to know how to use colours, the choice of which is basically no more than a question of habit.'

Remember that light and neighbouring objects affect each item's colour, so that, for example, the white sail of a yacht may vary from deep purple in the shadows to pale yellow in sunshine with very little actual white on it. Don't let your knowledge of an item's colour interfere with how you paint it. It may be made up of tiny blocks of many colours or large areas of just one shade. Paint what you see and you'll be pleased with the results.

It helps to know that an object's shadow contains its complementary (the colour opposite it on the colour wheel). So without any other reflected colour a red boat is likely to have green in the shadow. If the shadow is on water it is likely to contain some blue which is in turn reflected from the sky. If you find it difficult to see these things in real life, it may be helpful to examine paintings by other artists to see how it works.

Know your paints

Although experimentation is the best way to learn about paints, it helps to know a bit about their qualities before you start. Some are more powerful than others: for example, if you try to make a mix look bluer by adding cobalt blue you may find it takes forever to mix the correct colour. However if you darken it with Prussian blue, a strong tinting colour, you could easily overdo it. If you find that your mixes are always going wrong you could be working with a difficult balance of colours and trying to mix strong with weak. Try switching one of your paints to get a better balance.

Paints derived from natural pigments – ochre, the cadmiums and the madders – tend to be opaque with low to moderate tinting strengths. Paints made synthetically from carbon chemistry, like quinacridone magenta, are transparent with high tinting strength.

lemon yellow

cadmium yellow

yellow ochre

raw sienna

burnt sienna

cadmium red

alizarin crimson

French ultramarine

cobalt blue

burnt umber

Using the colour wheel

Nothing can help the artist better than experience derived from experimentation with colour, but an understanding of the colour wheel will let you know what to expect. It shows that mixing blue with yellow in various proportions produces a range of greens, for example. However, it is experience which will later reveal that to mix the clearest greens you must combine a greenish yellow such as lemon yellow with a yellowish blue such as cobalt or Prussian blue.

The colour wheel is also useful for finding a colour's complementary. Colours are best toned down by adding some of the complementary hue that appears opposite it on the colour wheel. The more you add, the closer it approximates to brown, grey or green; the less you add, the more it resembles its parent colour. Adding the complementary colour is also one of the best ways of producing natural-looking hues; mixing colours randomly can produce some very unnatural-looking shades.

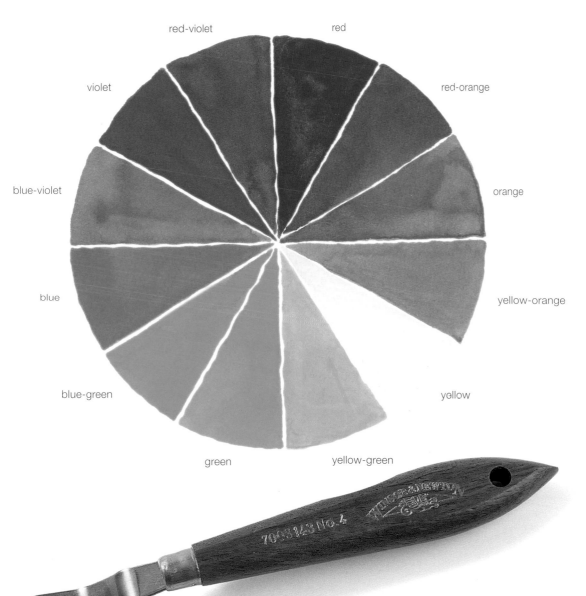

Artist's Own Technique

Whether you simply enjoy looking at paintings or whether you want to be an artist yourself, this section should be of interest to you. If you are an art lover, finding out a little more about how paintings are made will heighten your appreciation while if you want to paint yourself you'll gain some insight into how different artists work. Of course, the only way to develop a personal style and to really learn is to practice and experiment, but watching other artists will provide a few pointers.

Watercolour techniques

Watercolour is probably the first medium that comes to mind when thinking of seascapes and waterways, partly because great artists like JMW Turner used it extensively. Its light, translucent qualities are perfect for capturing the tenuous qualities of water and by allowing washes to merge together it is possible to shape form rapidly but effectively. This is particularly beneficial given that water is always on the move.

Oil techniques

Oil is the medium that most people think of when commissioning a painting. It is a comparatively slow medium to work and because the paint takes a long time to dry it gives the artist plenty of time to perfect the image. Using a series of overlaid glazes it is possible to give water a wonderful depth and a stunning translucency which is extremely lifelike. Oil is unlike most other mediums in this way.

Acrylic techniques

This medium often causes concern because it is so modern that we don't know much about it or how long it will really last. There is also a certain amount of snobbery in the art world which suggests that oil is the true aristocrat while acrylic is its very poor cousin. However, acrylic is fast gaining ground, mainly because it is popular with artists for its quick-drying properties and versatility it can be diluted to handle like watercolour or thickened to act like oil.

One possible drawback with acrylic is that the dried paint can absorb dust and dirt from the atmosphere which is then impossible to remove. You can get round this by varnishing the finished work with artists' picture varnish. This not only protects the paint but also enriches it, giving it a sheen which captures much of the look of oils. The varnish can be removed and replaced later on to restore the painting to its former glory.

Drawing media

Pastel is probably the most highly regarded drawing medium because other forms, such as coloured pencil, are more often associated with illustration. It has the advantage that it is highly portable since there is no drying time, but you do have to take care to avoid smudging. If you like to paint with the view in front of you it may be useful to have a can of spray fixative handy to prevent unwanted smudging during transportation.

Mixed media

If one medium doesn't offer the scope of expression that an artist requires, he or she is free to combine several to take advantage of the good qualities of each. Oil is sometimes combined with oil pastels while watercolour can be mixed with acrylic, inks (including acrylic inks), gouache and even poster paints. Ground pigments are also available in specialist art shops and these can be mixed with anything from milk or egg yolks to gum Arabic, beeswax or oil to create customised paint. Materials can also be added to paint including sand, plaster, texture gel and papers hand-painted or printed, to produce some wonderful textures. With so many exciting possibilities at their fingertips it is not surprising that a number of artists turn to mixed media for their figure work. Ultimately, of course, it is not which medium the artist chooses but what he does with it that counts.

SEASCAPES WATERCOLOUR

'Walking out to the headland at Studland there is no suggestion of the dramatic scenes which are to come; so it is a breathtaking surprise when one first sees the white slabs of chalk, brilliant in the sunshine and rising vertically out of the water. For thousands of years the sea has scoured the cliffs to form inlets, promontories and isolated stacks which stand in the water off shore.'

'On many occasions I have sat on the grassy edges to sketch in pencil, ink or watercolour and to take photographs. The painting of "Old Harry Rocks" is a response to the impact made on me by the brilliance of the afternoon sun on the white cliff face contrasting with the dark, dark blue of the sea 200 feet below me. Two small figures perched precariously on the cliff top give a sense of scale, vertigo and insecurity. The whole scene, to me, is one of grandeur and excitement, dramatically lit – and a ready-made composition.'

Old Harry Rocks by Ron Jesty watercolour on paper **34 x 51cm**

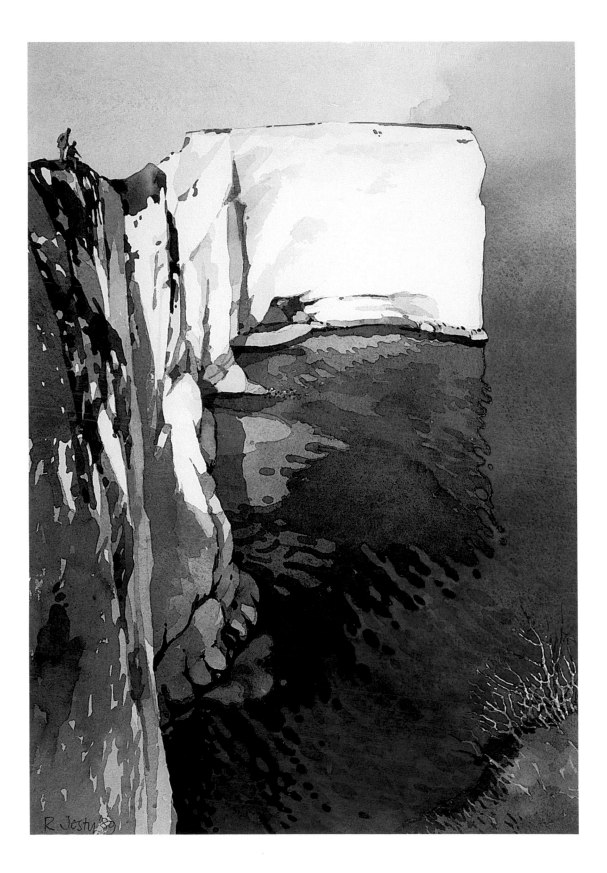

R. Jesty '89

Composition

Ron's experience as a graphic designer helped him produce distinctive compositions, leading him 'to seek out orderly arrangements of shapes, tones and colour, often with an underlying geometric structure.' His compositions are often based on the balance of contrasts – 'light against dark; large areas against patterns of small shapes; warm colours against cool; opposing colours.' The sea is an excellent 'feeding ground' for an artist desiring this type of subject since the bright light and reflections from the water produce wonderful contrasts, while there is a huge variety of topography too.

'For "Old Harry Rocks" I found a design of rectangles formed by the cliff face in the shape of its warm reflection below and the blue sea in the foreground. These are supported by the vertical cliffs at the left and the narrow strip of sea at the right.'

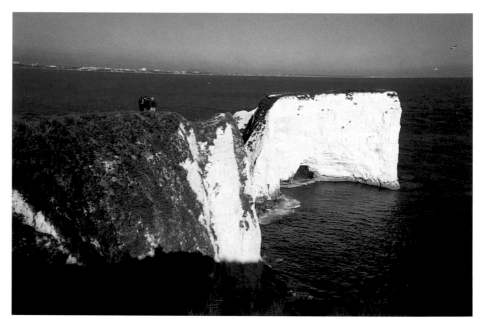

This photograph of Old Harry Rocks shows how realistic Ron's painting is in terms of topography but also how much better it is than a photograph at capturing the grandeur, height and drama of the scene. The photograph leaves the cliff face looking sadly flat and dull.

golden rule

Working with rectangles

Rectangles are solid, sturdy forms which tend to give an image a sense of balance and stability. They can be a little too static, however, and without other influences this could produce a rather 'dead' finish. To counterbalance these effects Ron has imbued his painting with movement, created by the drop from the cliff top to the sea and by the sweep of the rock as it reaches out. The struggle between the immovability of the rectangles and the energy of our eye movements produces the sense of overbalance which keeps us on our toes.

'In any painting I do, I must first be excited, thrilled or charmed by some special quality in the subject. Usually it will be something quite simple - a special kind of colour, a glint of light on the water or a feeling of drama or atmosphere in the weather. Often the "spark" is realised simply by making a little sketch, when the mental concentration and intense observation will reveal the special "something" which had not been noticed before.'

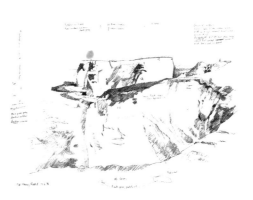

Focal points are placed to ensure that there is something going on in all areas of the picture. This draws us round and keeps us fascinated. Notice, for example, the two figures which lead us down to the sea, then round to the cave, and on to the bush in the bottom right.

Our eyes sweep back and forth on a diagonal between the two ends of the cliff at bottom left and top right. This tugs against the strong verticals of the cliff walls and creates a strong sense of movement which makes us feel unnerved and unstable, balanced as we are so high above the sea.

Ron broke down the scene in front of him into a series of rectangles. These strong forms give the painting great power and stability and help to convey the immense weight and monumental presence of the rocks.

Colour

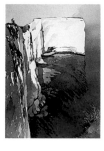

Ron tends to paint colours as they are. However, he also often paints from sketches in his studio, so the colours he uses are as he remembers them or as noted in his sketches – perhaps heightened versions of the real thing because of the emotions the scene has aroused. Like many good artists he also sees colours where other people might see a blank grey or brown. This makes for some wonderful combinations in the shadows of the white rock.

Notice the lavish use of colour in this sketch of Bull Point, North Devon (right). The rocks range from pink to violet and green as they catch and reflect the light.

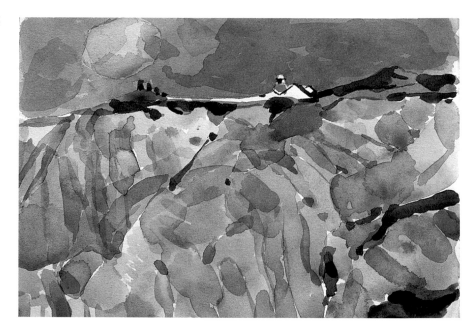

| lemon yellow | Winsor blue | French ultramarine | burnt sienna | cadmium red | French ultramarine |

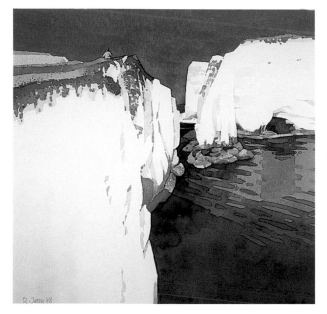

Handfast Point watercolour on paper **46 x 46cm**
A quick glance at this painting might not leave you thinking about the colour, but just as much effort goes into colour mixing where there are limited hues as it does where there is an explosion of colour. Look at how Ron has tinted the violet shadows on the side of the cliff and created the different tones in the water. They look so natural that we hardly notice them but we would certainly see the jarring note if he got them wrong.

The artist's palette

Ron has worked with Winsor & Newton artists' quality paints for many years. 'They are of a smooth consistency and an intense strength of hue which is invaluable when mixing and laying large washes of strong colour.' Ron works with an excellent palette which provides warm and cool versions of each primary plus two earth colours and from these he can mix almost any other colour. His palette comprises warm cadmium red, cadmium yellow and French ultramarine balanced by cool permanent rose, cadmium lemon and Winsor blue plus raw and burnt sienna. Occasionally he will also introduce other hues if needed such as cerulean blue, viridian green or permanent magenta.

Ron's colours all provide good lightfastness and other excellent qualities. The cadmiums, for example, are strong, clean, opaque traditional colours which mix well together and with other hues. You only need a little to go a long way. Winsor blue is another fine choice. It is a modern colour, also sold as phthalocyanine or phthalo blue, which is clean and intense. It is transparent, making it a wonderful choice for water, but it stains the paper so mistakes cannot be easily rectified.

cadmium yellow

cadmium lemon

French ultramarine

Winsor blue

cadmium red

permanent rose

raw sienna

burnt sienna

cad. red with lemon

cad. red with cad. yellow

'The work of the master reeks not of the sweat of the brow – suggests no effort – and is finished from its beginning.'

(James Abbott McNeill Whistler 1834–1903)

Technique

Ron painted the pictures shown in this book in his studio, using sketches as his references. 'Using this method affords infinite time for thought and consideration. On the other hand, conditions change quickly when working out of doors so that, usually, only a broad statement is possible, though with greater spontaneity.

'Essentially my way of painting in watercolour is quite simple and, to some extent, has become "standardised" after much practice. It consists of laying quite wet, flat washes on to dry paper stretched on a board which is horizontal or nearly so. However, when the need arises I will use graduated washes within defined shapes. Weak washes of colour are usually laid first to establish the general pattern of the composition and allowed to dry. Increasingly stronger washes are then laid over these, each being allowed to dry in turn until finally the darkest accents are added.

'I have no qualms or hang-ups about laying several washes over each other provided that those beneath are not disturbed and that colours are compatible. Rich colours and tonal effects can result in this way, as seen in the sea in "Old Harry Rocks", for example.'

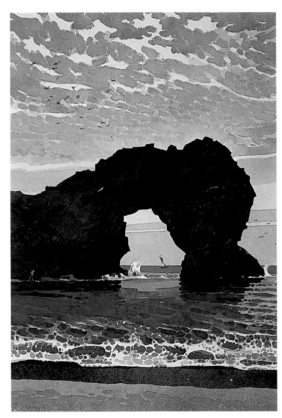

Durdle Door watercolour on paper
Ron doesn't favour masking fluid because it leaves a rather harsh, unnatural outline which he finds obtrusive. Instead he reserves white areas by drawing around them with the point of a wet brush. He did this for the surf breaking the shore in this painting which works very well.

pointer

Graduated wash

Sometimes Ron uses a graduated wash in his paintings which is simply a wash that shifts in tone from dark to light. It is quite hard to achieve a good, smooth graduated wash but it is a useful technique for creating a realistic sky, for example. Start by laying in a line of paint in a fairly strong mix then add water to the paint and stroke in another line of paint below it. Keep going, adding more and more water to each stroke of the wash so it gets lighter every time. Never be tempted to go back and fiddle with what you have done because your brush marks will show and you will only make things worse.

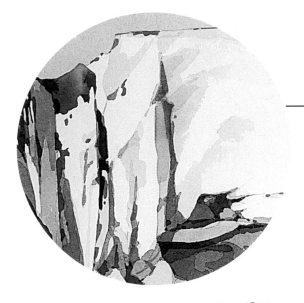

Painting white objects, such as these cliffs can be a difficult task. Ron makes them look whiter by applying some dark washes along the top and bottom with a range of tones in-between to suggest the undulating, fissured surface.

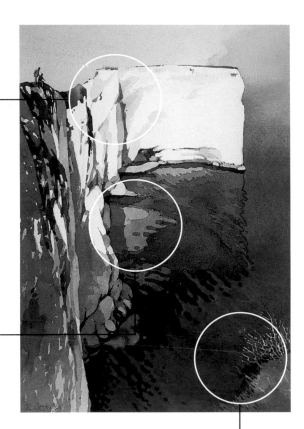

Ron reserved the white of this bush by outlining it first with a wet brush. This creates a softer look than would have been achieved with masking fluid. Notice how sometimes the branches vanish and then reappear just as they would in real life as the light and shadow play on them.

Ron applies washes layer on layer to build up the depth of colour required for the shadows in the water. This creates attractive colour variations and also helps to convey the increasing water depth.

SEASCAPES WATERCOLOUR

Peter Misson has the sea in his blood. His great-grandfather was a sea captain and several of his family were at sea, so it was no surprise that he took to it also and now has his Master Mariner's Certificate. 'I have experienced at first hand the vastness, majesty and power of the ocean. I have felt her breath under me and seen her serenity that often follows her anger. This has been my life and my inspiration.'

Yet despite his love and knowledge of the sea, he says 'the weather and light are the real subjects of my work. I want to convey a feeling of being there rather than give an accurate record of any place.' This desire is resonant of the artistic aims of the great JMW Turner (1775–1851), 'a master of atmospheric watercolour', whose work Peter much admires.

Gale Breaking Biscay by Peter Misson watercolour on paper **72 x 54cm**

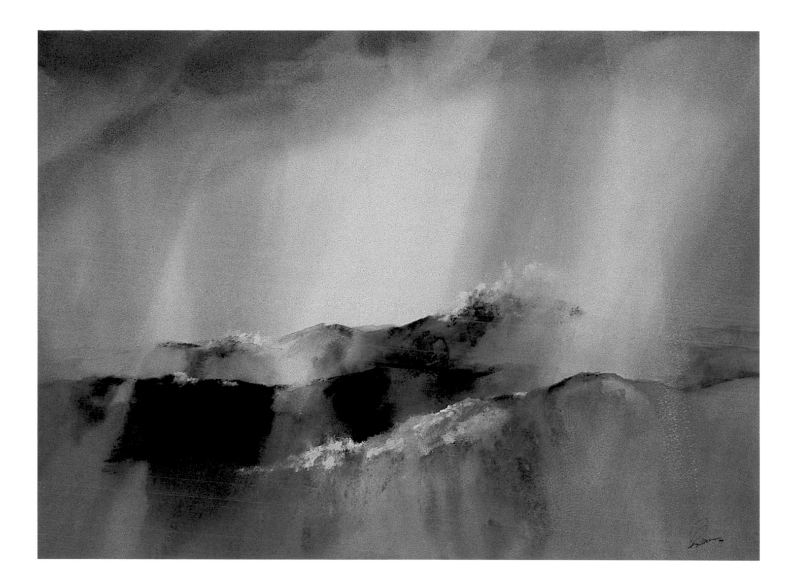

Composition

Sketching from life can be a tricky business at the best of times, but on a boat with its constant movement and with the buffeting wind and sea spray it can be even more problematic, so one might expect the artist to use photographic references. However, Peter spurns this option. 'Most of my seascapes are worked from pencil sketches made at sea, often on very small pieces of paper (I never use photographs).'

As a mariner Peter is drawn to features which are particularly interesting to seamen. 'Mostly I include something important to a mariner – a lighthouse or headland, for example. Indeed, lighthouses have recently become a bit of a theme in my work, especially rock lights – lighthouses on remote rocks, often in very hostile places – such as Bishop's Rock in the Scillies, the Wolf Rock or Eddystone off Plymouth.

'I work in the studio from my thumbnail sketches. The pictures seem to compose themselves when they work and I can switch off my brain and just let the memory flow. I can't really explain, but I push the paint about and I'm at sea. I think it was Degas who said that only when he no longer knows what he is doing does the painter do good things.'

These actual-size examples of Peter's sketches show how small he often works when on board his boat. Although the pencil sketch of Eddystone Rock is obviously brief (left), it's laden with atmosphere and the more detailed watercolour sketches have clearly caught the spirit of the sea (right).

Peter draws attention to the diagonal crest of the nearest wave by highlighting it in white and setting it against the inky darkness of the wave behind (see Golden Rule). By giving this diagonal more weight he infuses the image with greater energy because we feel the power as our eyes race along it.

Most seascapes are composed so that the sea fills the lower third of the picture area and the sky takes up the remainder. By dividing the support more or less in half Peter gives emphasis to the tremendous height of the waves – it is as if they have reached up from the lower section to take their place in the middle.

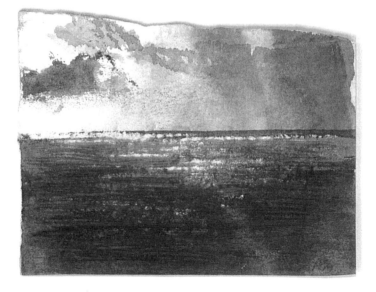

The furthest wave echoes the shape of the nearest one to reinforce the power of the diagonal. It stops short of the edge of the support so our eyes tumble over the end and we seem to feel the tremendous drop that follows the upward push of the wave, sensing the swell and fall of the sea.

golden rule

Counter-change

Dark tones set against light ones or light ones set against dark always catch the eye and can infuse a painting with energy. To emphasise or draw attention to a specific area of an image artists often deliberately heighten the contrast, a technique either known as counter-change, reciprocal tone, alternating contrast or induced contrast. They can also use this technique if a painting seems dull overall, heightening the contrasts generally to give it more sizzle. However, Peter didn't need to exaggerate the tones in his painting because the reflective qualities of water and the dramatic lighting of a storm combine to produce the most incredible natural contrasts.

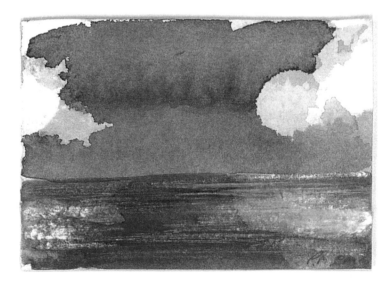

'Every glance is a glance for study.'
(JMW Turner 1775–1851)

Colour

'"What colours do I use?" is quite a difficult question for me to answer. You may as well ask "What colour is the wind? What colour is light or the thrill of being at sea in a breeze?" I am always amazed at the colours that appear in the sky at sea. You somehow never seem to see quite the same on land. The spray certainly helps, a sort of salt breeze hanging over the sea, especially with some wind, and that heightens the colour of the water.'

The artist's palette

Peter uses Winsor & Newton watercolours, choosing from both the artists' range and the cheaper Cotman range. He always tries to use the colours as they appear in Nature, never inventing them for effect. Although his palette varies he avoids green as much as possible and only mixes it himself, never using a tube green because he considers these rather nasty. In general his palette revolves around the primaries – red, yellow and blue. 'I always let the colours mix on the paper, using only colours straight from the tube and primaries that will keep the watercolour from becoming muddy. I use lots of water and lots of pigment.'

Gwenap Head watercolour on paper
50 x 31cm

'This is the first point to round after Land's End. There was a big swell at Gwenap Head so we could ease the helm and begin to run to Falmouth.' Notice the dramatic contrasts here, again ranging from the inky blue of the sea to the white of the spray. This time there is more colour in the sky, a rather sinister orange, which is reflected briefly in the sea. The landscape, depicted in a muted grey, has fewer contrasts and therefore has less importance in the composition, but it is strong enough so that it stays at the back of our minds, as doubtless it does for the passing mariners who cannot be allowed to forget the dangers posed by the rocks.

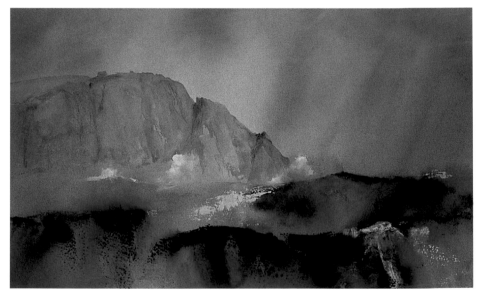

raw sienna cobalt blue

light red

yellow ochre

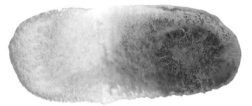

gamboge cadmium orange

cobalt blue

raw sienna

gamboge light red

Prussian blue

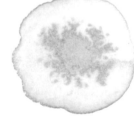

gamboge

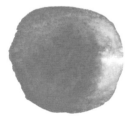

cobalt turquoise cadmium orange

pointer

About greens

Peter is not alone among artists in preferring to mix his own greens rather than buying them ready-made and there is good reason for this. For a start one can mix a good range of greens from blues and yellows, so why go to the expense of buying the colour specially? Also mixing ones own greens is a good exercise in using colour and should be encouraged. Additionally greens seem to fall into three categories: weak mixing colours, very strong ones and unreliable ones. Cobalt green and terre verte are very weak and rarely hold their own in a mix while viridian and phthalo green are incredibly strong and can overwhelm other colours. Olive green, sap green and Hooker's green vary depending on the brand, and although some good ones are around you have to be careful because there are also many which will fade or dull over time. If you do wish to invest in a green choose chromium oxide green which is a good mid green or select one of the strong colours – viridian or phthalo green – and use them with care.

Technique

'My technique has evolved over the years; a way of washing off and painting on and washing off that seems to add depth to the work. Turner used to plunge his work into tubs of water and work very wet. I've developed a similar technique. The ghost of the colour seems to stay after it has mostly been washed off and I build colour layer on layer until it's done. Most of my paintings take anything from five to ten washings, being thoroughly dried in between and I apply the paint sometimes on wet paper, sometimes on dry. I push the paint about and the image just seems to happen. Watercolours like this are a little like a crash landing; practice and knowledge sometimes let you take risks and get away with it.'

Bishop's Rock watercolour on paper **73 x 54cm**
Look closely and you can see the veils of colour here which have been built up by applying paint and then washing most of it off. Colour applied layer upon layer produces the wonderfully deep dark tones in the water while fewer layers give the sky its translucency. The textural effects produced by this process add to the appeal of the finished work.

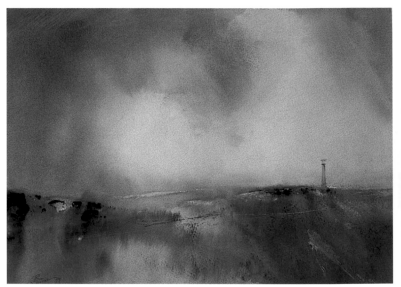

shortcuts

Washing off

Peter's technique of applying paint and then washing it off is not as straightforward as it might seem. Different watercolour paints have different staining properties so while some may wash away to leave just the faintest hint of colour others will stain the paper quite dramatically. You obviously need to have a good idea of how much the paper will be affected before you apply a particular colour. Experimentation is the key, but you can also refer to the paint manufacturer's descriptions to give you a head start. In the Winsor & Newton artists' range, for example, you'll find that Winsor blue and Prussian blue are both staining while cobalt will fade to just a hint of colour. Nearly all of the reds tend to stain as does cadmium yellow and about 50 per cent of the browns.

Bold vertical sweeps of colour in the sky capture the effect of light breaking through clouds after a storm. This effect lasts for only a few minutes so one has to be quick to record it to memory or on paper.

Sometimes Peter applies the paint wet-in-wet so that it expands and swells into neighbouring colours to produce some wonderful and often surprising effects, as on these turquoise waves.

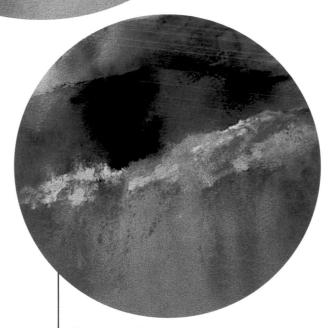

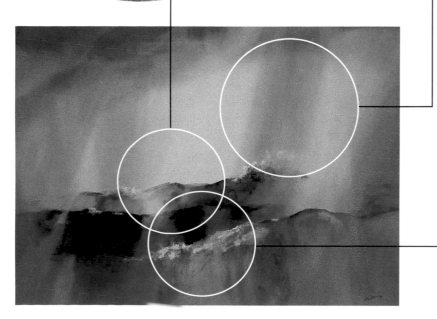

The use of white gouache is the only way of recreating the colour of the spray after Peter's painting and washing process is completed. It also adds an extra dimension to the work – quite literally – and gives it a painterly quality not dissimilar to that which is so admired in oils. It was for these qualities that Turner also used gouache.

SEASCAPES WATERCOLOUR

Cecil Rice has made over 20 trips to Italy, several of which have been specifically to paint in Venice. 'I tend to walk around the city in the first few days of the trip, doing small sketches in pencil, pen and watercolour. It was on one such foray that I first discovered the canal which featured in "Canal with Washing". This was a particularly dramatic, silent, narrow canal with sheer walls reaching up to what seemed like a chink of light. Several boats had been moored along the canal and washing had been hung out to dry in true Italian style between some of the upper windows. I sat down at the end of the canal to paint this watercolour on the spot.'

Cecil's motivations for painting particular scenes are mixed. 'There is no doubt that I am a romantic. I am attracted by the atmosphere of old and historic buildings, particularly Romanesque and Gothic architecture as well as dawns and sunsets, and if water forms part of the subject then this often makes for additional magic. Reflections in water have a life of their own whilst relating to other elemental parts of a scene. For example, in painting an enclosed Venetian canal one has the water reflecting the buildings which are solid and stony. The shapes of the doorways and windows are static but the reflections of these shapes in the water are moving.'

Canal with Washing by Cecil Rice watercolour on paper **35 x 25cm**

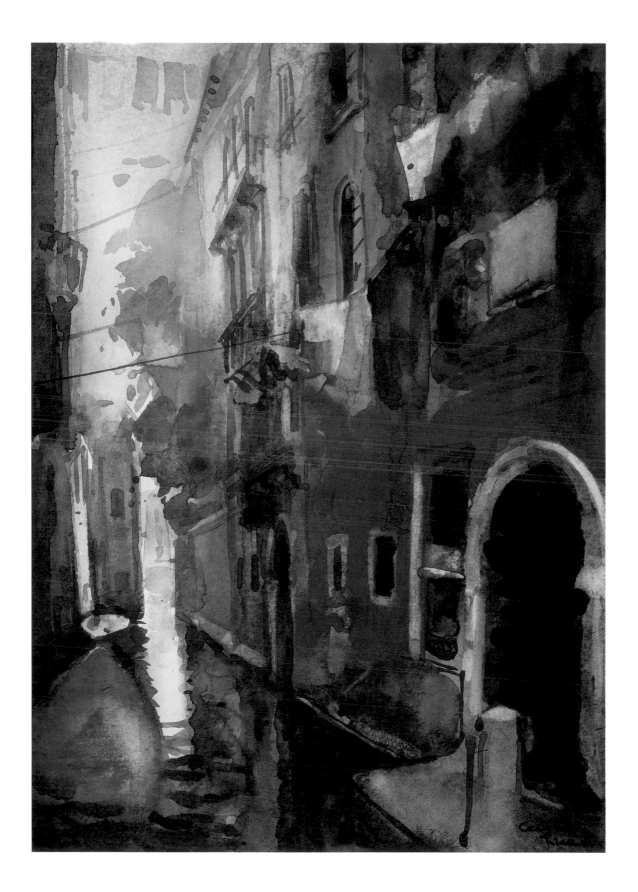

Composition

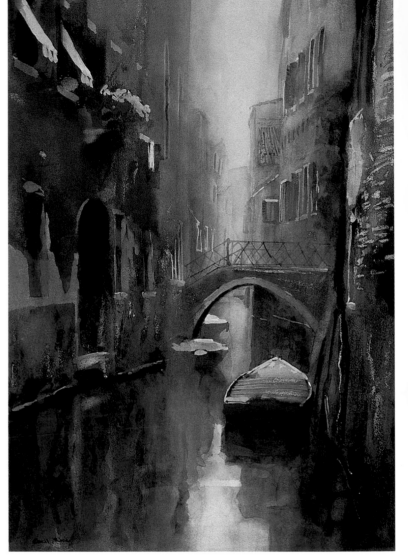

'I always seem to start with an intuitive idea of the completed painting. Then I have to decide what will go into the painting and what will fall outside the edges. I look at the view in terms of extremely simple shapes, but shapes which nonetheless lock together like pieces of a jigsaw.

'I believe in sound drawing at the outset and for this reason my preliminary sketch or sketches have to be accurate. In painting a canal I can't look for the horizon or its relation to the rectangle in which I will be composing. Nevertheless, it is possible to look for the edges of roofs, for example, and to notice the way that these shoot away in perspective towards a hidden point. Either side of the canal are many verticals – drainpipes, windows and even chimney breasts – which it is often useful to draw, either in light pencil or directly with a fine brush, so as to gain markers within the total composition.'

Canal, Venice watercolour on paper

The majority of waterscapes are painted in landscape format because this best suits the shape of the object being painted and creates a sense of openness and release which suits a lakeside scene or seascape. Here Cecil has chosen a portrait format because the atmosphere is very important to him and he wanted to capture the sense of narrowness – how the buildings almost fall in – which one feels in a small Venetian canal. Notice how the sides of the support brace the buildings, conferring them with additional solidity and weight.

As an added bonus the format gives Cecil plenty of space to play with the colours reflecting off the buildings and into the shadows. 'Looking upward in an enclosed Venetian canal may reveal a clear sky and the effect of Adriatic sunlight not only highlighting upper storeys but causing a tremendous light-filled warmth of colour penetrating down across the architecture. I'm attracted by how the brightest light in the painting gives way to the coolest of shadows.'

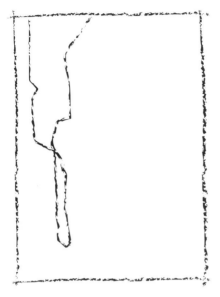

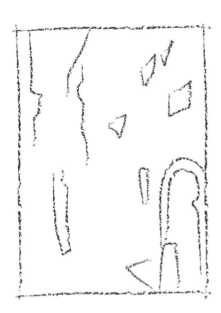

Cecil points out that with a canal scene there is often no horizon in view. This is the key line which most landscape or seascape artists start from in their compositions. Since he can't start there, Cecil uses the edges of the buildings as key lines instead, here plotting the opening between the rows of buildings close to the left edge of the paper. This off-centre positioning helps to create a sense of intrigue – twists and turns which arouse our interest and draw us deeper in.

Colour can be used compositionally as a means of leading the viewer's eyes around a painting. Here the clear, pale light at the end of the canal is echoed by the stark white of the enormous archway on the right of the picture and by some of the washing on the balconies and lines. Their contrast with the dark shadows gives them added drama to draw our eyes inexorably on.

Lines are another compositional device because we are naturally drawn along them. Here our eyes move rapidly from one side of the canal to the other along the washing lines; they dash up and down the lines of the balconies and windows and sweep along the bottom of the buildings. These lines contrast with the zigzag reflections in the water and the dappled foliage of the trees, keeping us constantly entertained.

golden rule

Getting references how you can

Although Cecil does make preliminary sketches in pencil, pen and watercolour, he likes to paint on site as much as possible, usually starting with quite a detailed drawing which he may erase as the painting progresses. However, life doesn't always run in the way we would like, and sometimes he has to make do with what he can get. When he returned to the site of 'Canal with Washing' with a view to making additional paintings, he found the view completely blocked by street vendors. 'I was so determined to get a second chance to paint from this vantage point that I slipped behind the stall and onto a very precarious sort of ledge. Realising that I was beaten, I whipped out my Nikon SLR and took a photograph, the only thing I could do without falling into the canal.'

Colour

Colour is obviously very important to Cecil since it overflows from his paintings with a radiance which is almost heart-rending. This is partly because of his interest in light, which is filled with the colours of life, and partly to do with his response to the atmosphere but it is also down to his inner eye. 'Many of my colours echo those naturally found in the subject but at the same time I quite often "see" a patch of wall or a tract of water inwardly as an area of pure colour. I can't explain this easily but it has to do with intuition and I often incorporate such an area into the composition as it reveals itself to me. Provided the addition of such an element within the design does not upset the sense of the painting as a whole it usually enhances the work dramatically.'

The artist's palette
Cecil uses a large range of colours, preferring Winsor & Newton artists' watercolours in 14ml tubes because they don't run out too quickly and they are slightly more economical. He also sometimes uses Rembrandt tube colours too. He mentally divides his palette into two sections – 'primary' and 'earth' colours. Under his primary palette he cites new gamboge, cadmium yellow, lemon yellow, cadmium red, alizarin crimson, French ultramarine, cerulean blue, cobalt blue and Prussian blue. As his 'earths' he lists yellow ochre, Naples yellow, raw sienna, burnt sienna, light red, Indian red, raw umber, Payne's grey and lamp black.

'In addition to these colours I usually allow myself the option of viridian. I use no other greens and I nearly always mix my own. I avoid pre-mixed versions such as sap green and Hooker's green as well as some of the more lurid or synthetic violets.' Although he includes Payne's grey and raw umber in his palette he likes to mix his own neutrals too, finding that this produces a much richer colour span. 'I particularly value the range of earthy browns, greys and violet colours one can get from mixing French ultramarine with either light red or burnt sienna. Cobalt blue and burnt sienna or light red also give a delightful range of shadowy colours. '

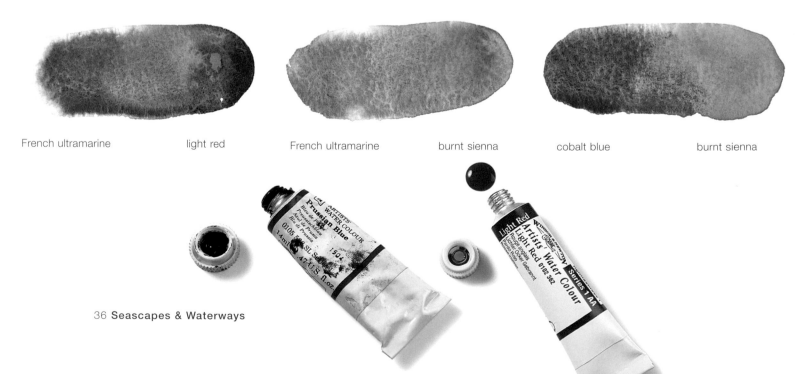

French ultramarine light red French ultramarine burnt sienna cobalt blue burnt sienna

pointer

Using a large palette

Cecil uses a comparatively large palette of some 18–19 colours. This is a lot to carry around for an artist who likes to paint on site, but it does mean that he can work with minimal mixing to keep his colours clean and vibrant. Instead of always mixing on the palette the colours can be allowed to merge together in places on the paper, creating some luscious new combinations.

new gamboge

lemon yellow

cadmium yellow

cadmium red

alizarin crimson

French ultramarine

cerulean blue

cobalt blue

Prussian blue

Naples yellow

yellow ochre

raw sienna

burnt sienna

light red

Indian red

raw umber

Payne's grey

lamp black

'You'll understand, I'm sure, that I'm chasing the merest sliver of colour. It's my own fault, I want to grasp the intangible. It's terrible how the light runs out. Colour, any colour, lasts a second, sometimes three or four minutes at most.'

(Claude Monet 1840–1926)

'There are many things to consider and many possible ways of starting a picture.'

Technique

Cecil starts his paintings with a light line drawing. This may be done with a soft, preferably 2B pencil, but sometimes he works directly with a brush, particularly if he is after a spontaneous impression. 'I don't bother with squaring up. If something looks wrong I rub out gently and correct it, and as soon as there is enough of a "scaffold" established I get the paints ready. I tend to try to foresee a good number of colours or mixtures of colours and I use largish mixing dishes for big paintings. I can start the actual painting in a number of different ways, sometimes by drawing thinnish lines with dilute colour or sometimes by soaking the stretched paper universally with clean water and a large, soft brush. I may wait for some of the moisture to penetrate the paper thoroughly and for some of it to evaporate, leaving a semi-damp surface into which I can work. I may start with a very thin colour cast using transparent colour such as new gamboge, raw sienna or Prussian blue.

'Having started the work I do tend to follow a logic relating to the tonality of the painting. It is traditionally thought to be a good idea to build up tone by degrees from lighter to darker in watercolour and I usually follow this principle to start with.'

shortcuts

Working wet-in-wet

Wet-in-wet work is a feature of most of Cecil's work and he finds that 'wonderful fusions of colour on the paper can lend a great deal to the build-up of atmosphere'. The technique sounds simple enough – you simply dampen the paper with clean or coloured water and then apply colours on top so that they spread and merge. However, control can be a problem. Although a certain amount of anarchy with this technique makes it more exciting for the artist and creates some spectacular, if surprising, results, giving the paint too much free rein can create dark tones where you want light ones and push edges out of position, for example. Cecil says that the dampness of the paper is a critical factor. 'If the surface is too dry or too wet then the paint will either form an undesirable solid mark or flow out uncontrollably across too large an area. If just right then the paint applied should be absorbed into the fibre of the paper, softly enhancing surrounding colours and forming an intensifying underlying colour.

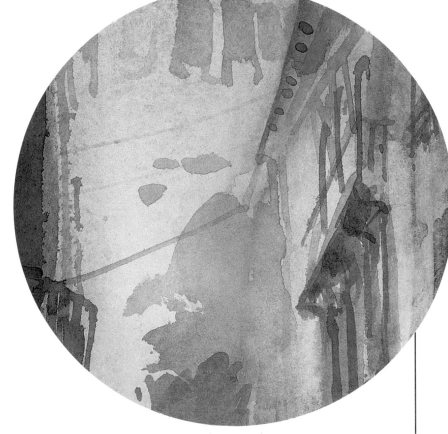

White objects are wonderful for artists who are interested in light effects and who love colour. They act like natural reflectors as light bounces colour onto them from surrounding objects. Sometimes they look genuinely colourful, but if not the artist can enhance them by adding colours, working instinctively or by design. Cecil fills his whites with colour, helping to show the way light filters down from the sky and creating a moody, romantic atmosphere.

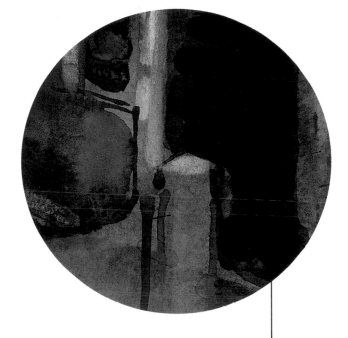

By applying translucent wash over translucent wash Cecil builds up shadows of great depth. Where washes overlap strange shapes appear and we are encouraged to peer deep into these areas in the same way as we look into real shadows to make out the partially obscured objects there.

The contrast between areas of wet-in-wet, like this, where colours merge, granulate and flocculate, and the areas of wet-on-dry like the shaft of light on the water where edges are crisp and hard, creates a visual excitement which makes the heart beat a little faster.

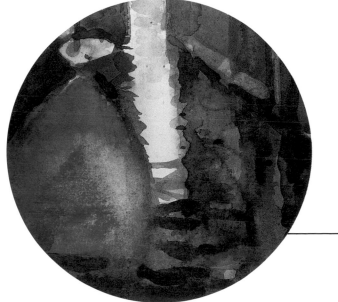

oils

SEASCAPES OILS

In 1990 Andrew Breslin and Robin Standeven began painting collectively with three other artists and formed what they jokingly called the 'Dead Artists Society' to hold a 'wake' for art. They imagined the root of art as 'a group of people sitting in a cave painting images on a wall which described their lives, fears, hopes, ideas and beliefs.' Would these people have painted alone? 'We could not imagine this as being anything other than a group activity.'

In 1994 the Dead Artists disbanded but Andy and Rob continued working together. They worked in a less linear and more painterly way, concentrating on recognisable subjects such as landscape and the figure. Their influences are 'every artist whose paintings have that visceral quality in which paint seems to transcend its metaphoric or correlative relationship to subject and appears, instead, as a convincing substitute for it.' They cite Titian, Delacroix, Gauguin, Willem de Kooning and Tintoretto as examples of painters who they feel exemplify this.

Land/Sky Rhythm by Andrew Breslin and Robin Standeven oil on canvas **56 x 66cm**

'Sometimes people accuse me of being incomprehensible only because they look for an explicative side to my pictures which is not there.'
(Paul Gauguin 1848–1903)

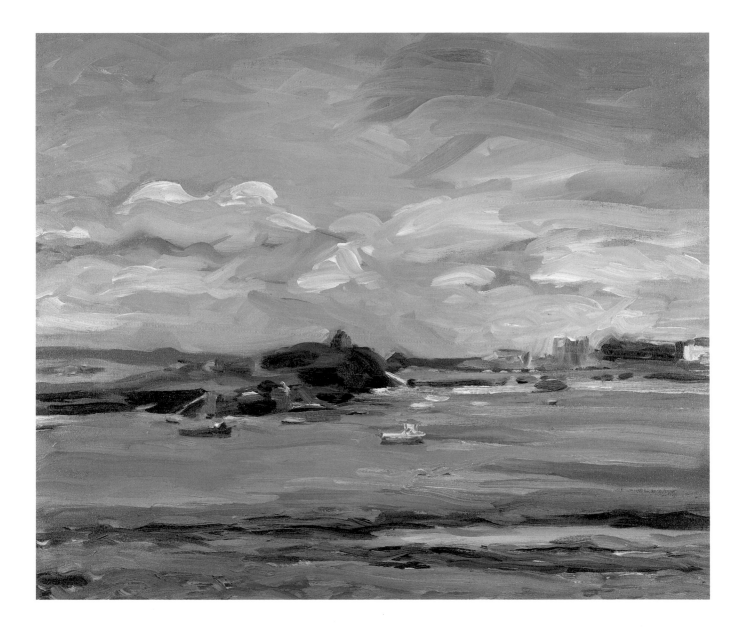

Composition

As with every aspect of their work, Rob and Andy work collaboratively on their compositions. When they were working as part of Dead Artists they would start with five canvases and 'rotate them so each artist could criticise and contribute. Working that way meant we managed to get away from a lot of the preciousness associated with art.' They still often take painting in turns or even sometimes work simultaneously, but they also make sure that they allot time for discussing the aim of the piece and their ideas for it.

Rob and Andy start with sketched references or even work from photographs. Although a painting begins with discussion, it grows organically, as one artist might 'make an initial mark and then the other will add something. Sometimes we take it in turns to stand at the canvas, but at other times we work on the painting together.'

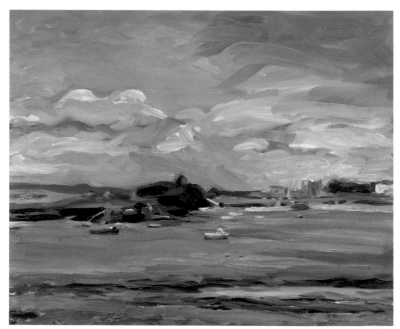

golden rule

Weighting the subject matter

Andy and Rob have given all areas of 'Land/Sky Rhythm' equal weight because the image is a focus in its own right with no one item more important than the next. This is actually quite difficult to do because a scene usually has its own inherent focuses and we are often drawn to a view by a particular item – the shape of a land form, the colour of the sea or the juxtaposition of sailing boats and buoys. It is hard not to place your 'subject' prominently and to spend more time caressing it with the paint. Making an item large, placing it in or near the centre of the support and giving it more detail will all draw attention to it, so if you don't want this to happen you must be careful to place it in a less conspicuous place and don't make it more detailed than the rest. Contrasting colours, such as bright red on a mainly blue support will leap out too, so if necessary tone down the natural colours so that no single object stands out.

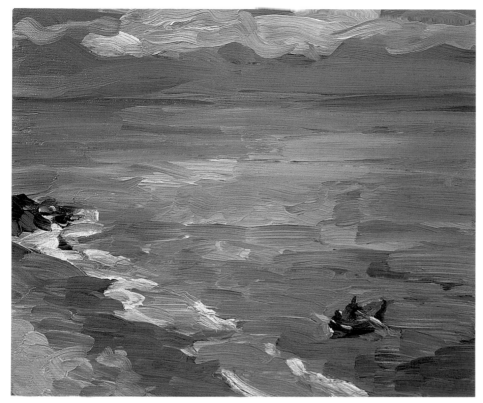

Gold on Shore oil on canvas **30 x 25cm**
This is an unusual composition and it exemplifies how working as a team instead of individually can produce innovative results. When working alone it is easy to lose confidence and take the conventional route, but with someone else to say, 'Hoy, that works', or, 'That looks awful', there is more impetus to push experimentation forward.

In this painting we might expect the rowing boat to be the main focus of attention, yet its small size, its position in the bottom corner of the canvas and its lack of detail make it less significant. Another focus might be the clouds but here they have been cropped, making us look beneath them instead of at them. We find ourselves looking between the clouds and the boat at the real focus of the picture which is the sea itself, and in particular we are drawn to the waves on the shoreline by their bright, light colour.

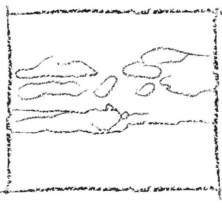

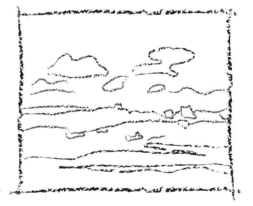

Flat horizontals create a very restful mood in an image, and here there are several where land meets water, making the lower half of the image quite stable and contemplative. If very dark, flat or dull colours had been used here it would have created a rather black mood, but the pale greens and lively brush marks give it a sunnier feel.

The top half of the image is more buoyant and lively than the bottom. The fluffy white clouds are swirled in energetically and there are rounded forms on the landscape too which create a jolly and friendly mood. Notice that the colours blend in to one another here – too much contrast combined with bold brush marks can make a sky look heavy.

Usually artists select one or more item(s) to be the focus in a painting and give it a prominent position on the canvas. They also generally give it the most attention and detail. But although this is a painting which shows a landscape, it isn't about that landscape or an object within it. The painting has become an object in its own right.

Colour

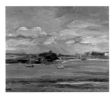

Most of the collaborative work by Andy and Rob has a high colour key with rich, bright colours which embolden the spirits and uplift the heart. Perhaps this is because they find working together to be an energising and encouraging experience. As Andy says, 'Working in isolation can be difficult. We have had calls from artists who are going through a dry period who ask us if they can join us for a while to help get them motivated again – we are like an art clinic in a way.'

The artists' palette

For 'Land/Sky Rhythm' Andy and Rob used a palette of 12 colours plus white which they mixed with boiled linseed oil and pure turpentine to create a smooth, translucent consistency. They used paints from four manufacturers, Winsor & Newton, Talens (Rembrandt), Maimeri (Classico) and Rowney and point out how very different colours which share the same name can be depending on the manufacturer, not just in terms of texture which varies from stiff and paste-like to really quite liquid, but also in terms of colour which can differ quite considerably. Although manufacturers would like to encourage us to be loyal to their brand, there is usually no problem with selecting from various makes to find exactly what you want. However, do note that if you can't find the colour you want in the brand you are used to, another manufacturer's version will not be quite the same.

So Below, the Mountain oil on canvas **30 x 25.5cm**

The light in Scotland tends to be cool in tone, just as it is in the Scandinavian countries, so for this painting of a mountain in Invernesshire, Northern Scotland, the artists have picked a cool, greenish blue for the water and sky, balancing it against warmer, pinkish blues in the shadows of the mountain. Here the tone is warmer because the shadows are reflecting some of the colour cast by the rising or setting sun. Notice that although the sky and water are cool, they are far from mute, reflecting, perhaps, the artists' joy at the scene.

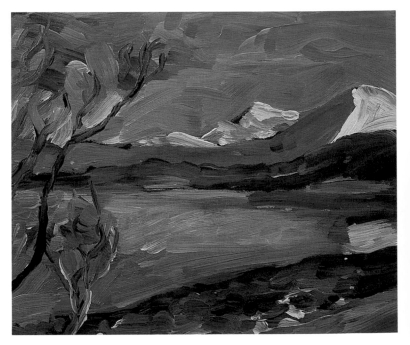

yellow ochre

burnt sienna

scarlet lake

cadmium red

cobalt violet

French ultramarine

cerulean blue hue

cobalt blue deep

emerald green

sap green

terre verte

raw umber

emerald green cobalt blue deep

cobalt violet French ultramarine

burnt sienna scarlet lake

pointer

Painting in a particular colour key

Rob and Andy tend to work in a high colour key which produces vibrant paintings that raise the spirits. To paint in a particular key, like them, you need to know something about the quality of your paints and the pigment(s) they are based on. To start with each pigment has its own in-built intensity and ability to reflect or absorb light. If a pigment has a high intensity and reflects a lot of light it has a high key. Phthalo blue and cadmium yellow have high keys, for example, while rose madder and yellow ochre have low keys. Most of the inorganic pigments – those derived from natural minerals or ores like cobalt blue – have a low key, while the modern organic pigments which are synthetically made in laboratories tend to have a high key. These include colours such as quinacridone magenta or phthalo blue. Check with the paint manufacturer's written information to find out which colours suit the key that most appeals to you. Then, once you have selected paints which fall into that category, all you have to do is get painting.

Technique

Rob and Andy collaborate at every stage of their work. They start by discussing concepts and colours and then work from sketches or photographs to put their ideas down on canvas. Far from hampering progress by causing conflict, as some artists might expect, this method actually speeds the whole process up and the artists say that they work at incredible speed. 'If you are on your own you paint a little and then stand back and work out what to do next. If you're with someone it speeds up the whole creative process. We do argue sometimes, but we've never come to blows.'

You might also wonder whether the styles of two people might produce conflict on the canvas, but Rob and Andy say that style, which reflects the personality behind the work, is something which they question anyway. 'We try to concentrate on the painting rather than who has done it.' Doubtless, also, two people could not have worked together so successfully and for so long if they were not in essential agreement about where they wished to take their work.

shortcuts

Art in its own right

If, like Andy and Rob, you believe that a painting is more than simply a copy of Nature, that it is a piece of art in its own right, then the physical properties of the piece become more important. This means that the brushwork takes on greater meaning. Bold brushstrokes can follow the shape of a wave, for example, so that they don't just describe form but transmit energy and build body, giving the painting an extra dimension. You can use other techniques too, such as drybrushing or tonking to create other textures. Colour, too, takes on greater importance because you aren't just copying what you see. Instead the view becomes a jumping-off point for your own concepts and you can use colour to transmit emotion.

The boats on the lake and by the far bank add human interest along with the buildings. Details here have been kept to a minimum to discourage our eyes from spending too much time looking at any one area of the picture. The artists' aim is to create a whole, not a succession of parts.

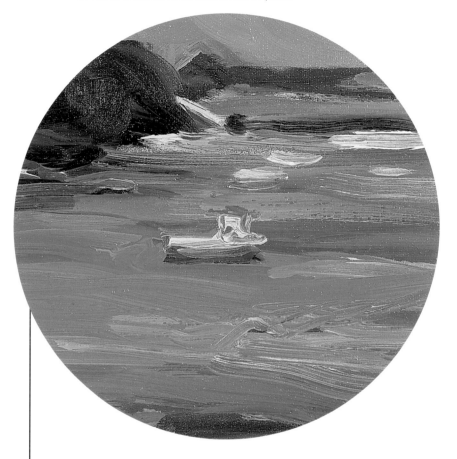

Energetic, curvaceous brushstrokes give an energy to the sky and help to give the whole painting a lively and positive mood. Notice how some areas of the sky have been blended while in other areas the bold brush-marks have been left to stand. The blended areas provide quiet sections which enhance the brushstrokes through contrast.

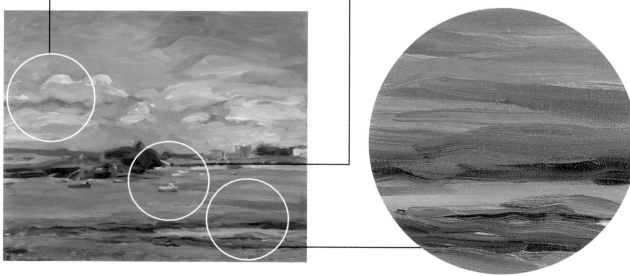

In accordance with the rules of aerial perspective Andy and Rob have made the foreground areas warmer than distant regions. Here the greens are olive with touches of yellow and red. Notice, however, that there is no more detail here than in the background. This is because the artists wish to make it clear that they are not attempting to produce a copy of the place but are aiming for something more.

SEASCAPES OILS

For nearly a decade Michael Major has returned to the Norfolk coastline to find the inspiration for his paintings. It is a somewhat bleak site, blanched by the summer sun and driven bare by harsh winds so that to many it appears hostile and unapproachable. It is a place that Michael himself describes as 'unpicturesque' yet its desolation is also mesmerising with a dream-like quality which is hard to shake from the memory. Michael is particularly affected by the spectacle of natural lighting – 'odd shifting angles of light and the feeling of transparent space; emptiness,' – which he puts into his paintings through the vibrant use of colour applied in many-layered glazes.

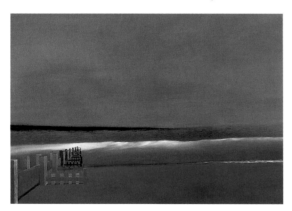

opposite **Quiet Drama by Michael Major** oil on canvas **61 x 92cm**

left **Evening Glaze by Michael Major** oil on canvas **117 x 168cm**

'Nature does not stand still.'
(Claude Monet 1840–1926)

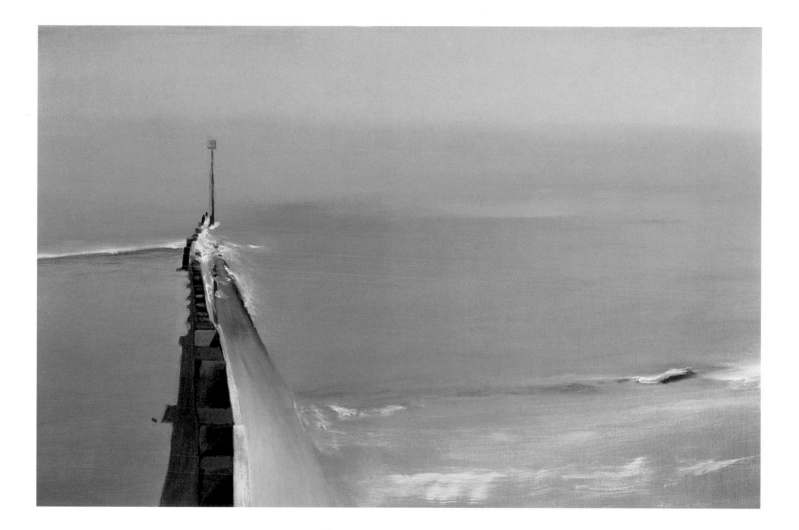

Composition

Michael makes pastel drawings on site at the Norfolk coast for his reference but creates his paintings in London, 'allowing time for memory and the imagination to work'. For him the visuals of the scene are just the starting point since a photographic copy is incapable of recreating the emotional experience of being there.

The stark landscapes of the coast are the perfect base for the look that Michael wants, but more and more he is tending to simplify the subject further, including fewer and fewer of the man-made structures that identify the scene such as beach huts and breakwaters. For him the elements of air, water and stone are sufficient to express his meaning.

Michael's compositions often balance large, empty expanses with smaller, much busier areas, as in 'Evening Glaze' where he has dropped the high horizon line that he usually favours to give plenty of space to the flaming orange sky. Crop the image down to a more conventional picture centring on the breakwater and you are left with a far less dramatic image.

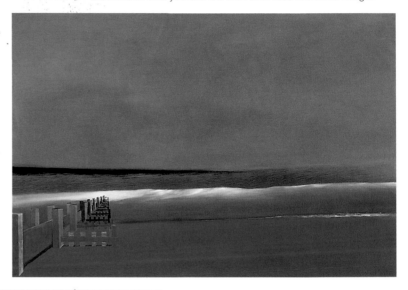

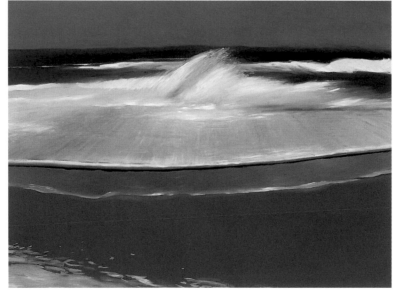

Sand Bank oil on canvas **89 x 122cm**
Michael is moving towards less cluttered imagery, as here, where the painting concentrates on the way sea communes with shore. The single splash is positioned just above centre, drawing our attention but giving plenty of space to the rendering of the steadily spreading water in front. Notice the way he has captured this perfectly flat vanguard of sea which moves silently and inexorably on.

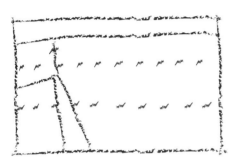

Most seascapes are divided horizontally into thirds, with the sky taking up the top two-thirds and the sea dominating the lower third. Michael has adopted these proportions but he places the sand and shallow water in the lower two-thirds, squeezing both sea and sky into the top third. This has the effect of giving the image a more abstract feel.

Whether you first 'read' the picture from bottom to top or from left to right you are directed to the same point at the end of the breakwater where sea batters shore. Either you are shot there by the sweep of the breakwater itself or led by the sharp line dividing sea from shore. This is where most of the activity is centred as the waves splash against the wood.

Good composition has a lot to do with balance and counterbalance. Balancing the energy created by the angled line of the breakwater is the solid, static vertical of the metal post and the less distinct horizontal created where sea meets sky. These have a calming influence so that as we rush busily forward we feel a sudden release of tension.

golden rule

Recessive and advancing colours

Tiny particles in the air act like veils to make colours appear bluer and less distinct the further they are away. Artists wishing to recreate this effect of aerial perspective use cooler colours to suggest distance and keep warm, bold colours in the foreground. In 'Quiet Drama' the strong indigo on the breakwater at its furthest end combines with its narrowing lines to make the breakwater recede, but the sky is not pressed right to the back because some of the warm ground colour shows through. This creates a kind of sparring match as the breakwater pushes back while the sky presses forward, adding energy and power to the image.

Colour

Although he works from coloured pastel drawings, Michael lets memory and feeling come into play. 'My colour is heightened and sometimes completely invented with the idea of an equivalent which gets closer to the original experience while moving away from the literal.' In 'Evening Glaze', for example, Michael heightened the colour and invented the sky, glazing successive layers of rose doré over the raw sienna ground. 'This vibrant sky helps to electrify the French ultramarine blue and phosphorate the white.'

The artist's palette

Michael's palette varies but he particularly favours raw sienna, Indian yellow, rose madder, rose doré, Venetian red, cobalt violet, cobalt turquoise, French ultramarine, indigo and sap green. This sounds very different from the standard artist's palette, but what makes it really fascinating is that all except one of the paints – Venetian red – is transparent, and Michael mainly uses this to colour the ground (see Pointer). Michael does use other colours as needed so that he can play off his favourite transparent colours against more translucent or opaque ones, but it is his lavish use of transparent colours in a glazing medium of oil and varnish (see overleaf) which enables him to capture the luminosity of the seashore and to instil his paintings with a mystical quality.

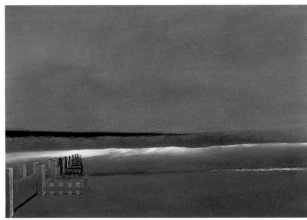

Venetian red (over) Indian yellow

cobalt turquoise (over) raw sienna

rose doré (over) raw sienna

raw sienna

Indian yellow

rose madder

rose doré

cobalt violet

cobalt turquoise

French ultramarine

indigo

Venetian red

sap green

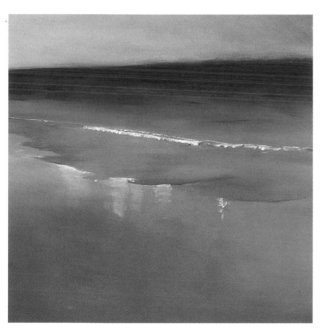

Thin Skim oil on canvas **91.5 x 91.5cm**
Raw sienna is the perfect basis for sand and
Michael has often used it as his ground,
painting the whole support in raw sienna and
leaving it to dry before beginning the painting.
This is particularly appropriate here where
layers of turquoise are applied to build up the
depth of the water and recreate the way it
lies over the undulating sand.

pointer

Coloured grounds
Colours always take on a little of the hues next to them and it
can be difficult for an artist to judge the final effect of a colour
when placing it on a white support. For this reason many oil
painters begin by tinting the whole support in a soft tone
against which they can plot the colours of the image. A pale,
warm tone such as raw sienna tends to be most popular
because a dark colour will obviously darken the paints laid on
top and a warm hue is more life enhancing than a cold one.
Additionally, a coloured ground can help to unify the painting,
particularly if portions are left unpainted around the support. If
this is to be the case then an appropriate colour must be
chosen – in general a natural colour blends in best.

Technique

Michael always works on pre-primed Belgian linen canvas, starting with a coloured ground – raw sienna or Venetian red and most recently Indian yellow. 'There is minimal drawing on the canvas, with great interplay between transparent, translucent and opaque oil colour. Frequently areas are built up in successive layers of transparent colour.'

To heighten the transparency of his colours Michael uses a traditional but now less commonly used medium comprising equal parts of damar varnish (see Shortcuts), linseed oil and turpentine. If you decide to adopt this medium too, keep in mind the golden rule of working fat over lean, using less oil (or no added oil) in the early stages of the painting and more towards the end. This helps avoid cracking which can occur when fast-drying oil-light paint is applied over slower drying oil-rich paint.

shortcuts

Damar varnish

Damar varnish is a highly reliable natural varnish made from damar resin (which comes from trees) and white spirit. This varnish enhances colours with minimal gloss and yellowing and does not crack or become opaque with age. It is particularly good at giving brilliance to glazes but it is generally used these days to create a protective layer over oil paintings, prints, maps and drawings.

The brushstrokes of the breakwater, in indigo and white, lead us speedily towards the main movement in the painting – the turbulent water at the end. This white spray is applied with thick white paint as one of the final touches.

By applying successive layers of colour Michael was able to build up the intensity of the yellow-orange sand, given brilliance by the sun, until it seems to glow with its own light.

Layers of transparent cobalt blue were skimmed over the Indian yellow ground to give the shallow water a wonderful translucency.

SEASCAPES OILS

Jiro Hyoda paints from life, opening his mind to the sensations of being in a particular place at a particular time and trying to communicate some of these emotions to the canvas. Sometimes, he says, he gets so involved with the subject that he even talks to the object he is painting. He is very modest about his work, seeing himself as a medium who relates the wonders of Nature onto canvas. 'I am merely an illustrative tool used by Mother Nature to convey the beauty of creation,' he says. Yet interestingly his urban waterways show much of the influence of Man – river walls, bridges, jetties, boats, cranes and so on. For him Nature includes these things since they too are part of life.

Osaka Bay by Jiro Hyoda oil on canvas **92 x 73cm**

'My aim in painting has always been the most exact transcription possible of my most intimate impressions of nature.'

(Edward Hopper 1882–1967)

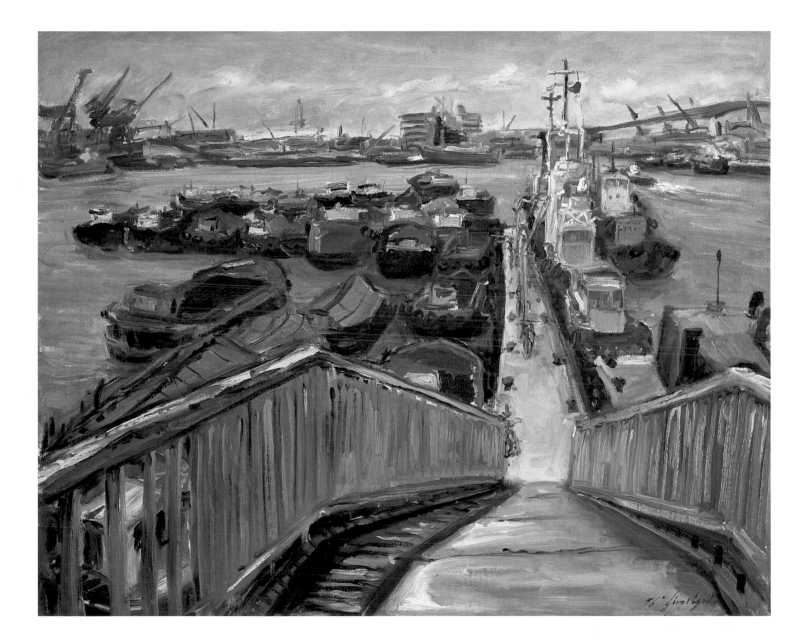

Composition

Composition has an important role to play in enabling Jiro to put feeling into his work since it can set the tone, creating calm or excitement, happiness or anger. In 'Osaka Bay' Jiro allocates over a third of the picture area to the jetty and walkway. Instead of just showing us the view Jiro brings us exactly to the place we would be when initially viewing this scene, helping to recapture the excitement of seeing it for the first time with the exhilarating feeling of height and the inviting sweep down to the boats. The temptation to hurry down the walkway to get a closer look at the boats is overwhelming.

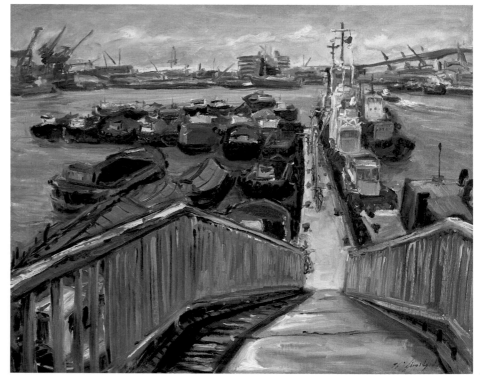

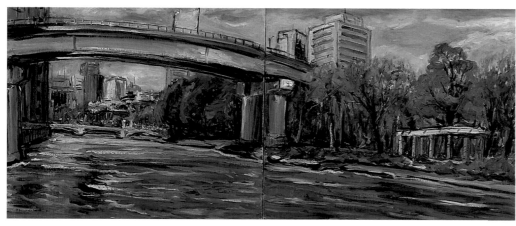

Osaka Nakanasima oil on board **60 x 146cm**
There is a good rule that the artist should work as large as he needs to, and not feel confined by the size of the support. Jiro needed the space of two supports to fit in this sweeping bridge and the water flowing beneath it so he simply painted both and hung them together. Artists more often do this with sketches, attaching extra paper to the main sheet to give space for the composition. This releases the artist from the temptation of condensing an area of the image to fit it in, thereby distorting the subject.

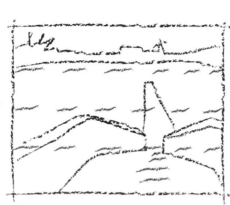

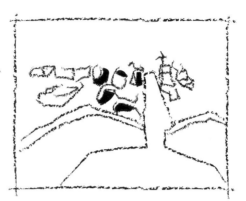

The first thing that strikes the viewer when looking at this composition is the dramatic sweep of the walkway down to the jetty. Paths and roads always load the eye in a composition and they can be a useful device for the artist to direct the viewer to certain focal points. Here the walkway points us not just to the boats but also on to the activity taking place on the far side of the river.

Most artists plot the horizon line along one of the thirds (see Golden Rule) but Jiro has pushed it up as far as it will go, giving less than a quarter of the picture area to the sky and buildings on the far bank. This gives him maximum space to concentrate on the busy activities of this working river.

The boats are clearly the main focal points of this painting. Not only has Jiro placed them in the centre, but he picks some of them out in bright primary colours. In a painting of generally pale, cool tones, these stand out like flags to attract the eye.

golden rule

The Rule of Thirds

There is a guideline for artists called the rule of thirds which says that dividing the support roughly into thirds both vertically and horizontally creates the most pleasing proportions. These divisions can either be used to mark out separate areas, such as sea and sky, or can be used to place features such as a large boat. However, if all artists always did this then art would be very dull and it is often the case that more eye-catching results can be achieved by breaking this rule. For example, Jiro has pushed the horizon above the top third to give him more space for the water and to create an unusual and therefore striking format. Notice, however, that he places the jetty on one of the vertical thirds. This is where we have grown to expect features to be placed and it helps to give the image greater stability.

Colour

Jiro tends to paint colours as he sees them, emphasising them here and there to help create the right balance in the painting or to infuse the image with more meaning. For example, he has perfectly captured the grey-blue of a smog-ridden city sky in 'Osaka Bay', not trying to romanticise it or clean it up. Notice, too, that the whites on the boats have been greyed, just as they really look in this setting.

The artist's palette

Jiro chooses from a large selection of some 24 colours. Although he may not use all of them in one painting he likes to have them at his disposal. These include many traditional colours such as the cadmiums – cadmium lemon, cadmium yellow and cadmium red – plus several earth colours and Vandyke brown. The cadmiums and earth colours generally have excellent strength and lightfastness, making them a good addition to any artist's palette.

Among the earth colours Jiro uses is terre verte. This was originally made from a coloured clay, but since most of the good deposits of this clay have now been used up, many modern versions are strengthened with dyes and other pigments. This is no bad thing since it improves the quality of the paint, both in terms of handling and lightfastness.

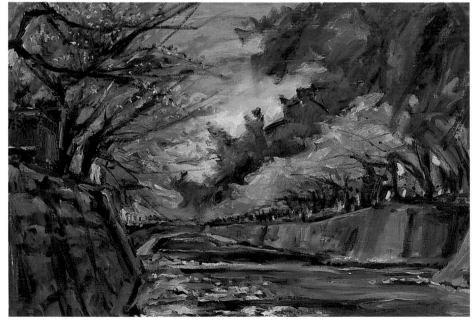

Nisinomiya oil on canvas **65 x 54cm**
Colour does many things in a picture. It can draw the eye, alter the emotions or set the scene. Here, for example, the pale pink of the fruit blossom lining the river indicates that this is spring or early summer. Combined with the warm blue of the sky it sets an uplifting tone and reminds us that we can see the beauty of Nature even in the heart of the largest cities.

pointer

Paint what you see, not what you know

There is a trap that beginners often fall into of painting things in the colours they know them to be – masts in white, for example – and not painting them as they really look. Light will always change the colour of an item, as will the objects next to it since some of their colour will be reflected onto your subject. To avoid this trap Monet advised the artist to 'try to forget what objects you have before you: a tree, a house, a field or whatever. Merely think, here is a little square of blue, here an oblong of pink, here a streak of yellow, and paint it just as it looks for you...' Notice that Jiro has not fallen into the trap of painting what he thinks rather than what he sees – his whites are greyed by the dull light and not painted in the bright white of a clear, sunny day.

 yellow ochre
 burnt sienna
cadmium lemon
cadmium yellow
cadmium red
alizarin crimson

 French ultramarine
cobalt blue
Prussian blue
terre verte
Hooker's green
viridian

 raw umber
burnt umber
Indian red
Vandyke brown
mars black

 Indian red burnt sienna
 Prussian blue viridian
 alizarin crimson cadmium lemon

Technique

Jiro always paints on a coloured ground, never working directly on the white of the canvas. He starts by tinting the support with a thin wash of pale brown, a soft neutral which he considers the perfect basis for all subjects – 'grass, water, human skin, sunlight and any highlight can be painted more clearly over this colour.' Indeed, he even finds that he can paint white better over this tinted ground than over the white canvas. This is because the white of the canvas is flat, whereas the white of reality is tinted by life, by the objects around it and by the colours of light.

Jiro allows the colour of the tinted ground to show through in the final painting. 'It becomes the bottom of the river and I paint the water over it.' He builds up the image in stages, finally adding the highlights with slightly thicker paint to ensure that his whites look bright and to provide textural interest.

shortcuts

Letting brushstrokes stand
Some artists seem to want to hide their own hand, brushing out the paint into smooth layers and obliterating the brushstrokes and other signs that the artist has been at work. However, these marks represent an entire element of the painting and to remove them is to deny the viewer a whole facet of art. Without them we see less of the emotion and activity that has been put into the work and the piece can lose its freshness. Jiro works boldly and confidently, allowing us to see every stroke and thereby filling his paintings with energy and life.

'The difference between a bad artist and a good one is: the bad artist seems to copy a great deal; the good one really does copy a great deal.'
(William Blake 1757–1827)

By reducing the detail on the opposite side of the river and softening the outlines Jiro emulates the effects of aerial perspective to push these elements into the distance. Notice that colours are softened here which is also a natural effect of distance.

Notice how sparingly Jiro uses his brush. Single sweeps of paint form the sides of each boat while the tyres are plotted in two shades, again applied with bold sweeps of the brush. This is just enough to give body and form without overworking the image.

Jiro makes no attempt to render every bar of the hand rail exactly. Instead he sweeps in long strokes in several shades of blue to create the overall effect. By allowing the warm brown tone of the ground to show through, he creates unity and harmony in the painting.

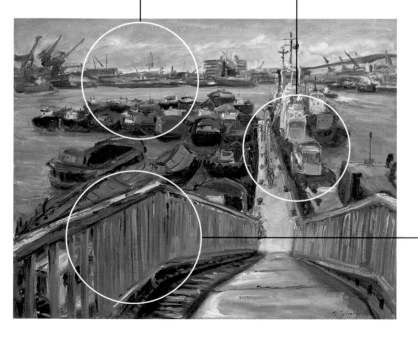

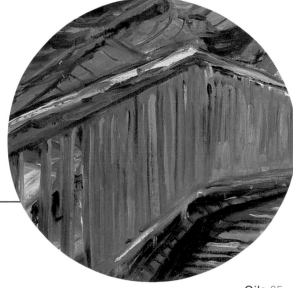

pastels

SEASCAPES PASTELS

The Lincolnshire coast from the Humber to the Wash is Keith Roper's constant inspiration. He is moved by its every aspect – 'continuous flat sand with salt marsh and mud flats, tidal crooks, sand hills, river tributaries, its big skies, cold North East winds and heavy summer sunsets.' He also likes to paint along the Solent, approaching the subject in the same way, 'walking the shoreline, trying to capture the mood and atmosphere, using the outline of the Isle of White as a backdrop and contrast, the hint of a sail as a focal point.' Wherever he is, 'land, sea and sky provide a constant source of inspiration and subject matter.'

Low Tide, River Eau, Saltfleet by Keith Roper pastel on paper **33 x 28cm**

'... and after the great waters break
Whitening for half a league, and thin
themselves, Far over sands marbled with moon
and cloud, From less and less to nothing.'
(From 'The Last Tournament' by Alfred Lord Tennyson 1802–1892)

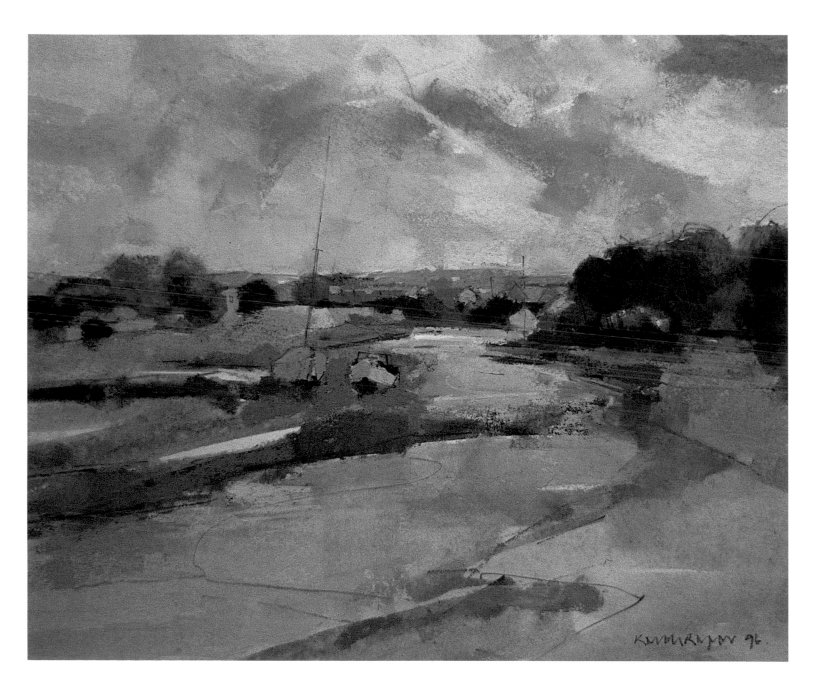

Composition

'I generally begin by dividing my paper into thirds and also into halves or quarters. I don't decide where to place the horizon until I start to put on a colour wash, and then I usually plot it between the lower third and the centre line or the upper third and the centre line. I work from slides, using them as references, never copying the actual slide.

'I start with a particular idea in my head of what the final picture will look like. Sometimes it doesn't work out, which is disappointing, but with pastel you can always wash it off and start again. When dry, the stains of the painting are quite interesting and can be the starting point of a newer picture. It's a question of trial and error until you finally succeed. The way the colour wash dries can also determine the composition of the picture – you might see a completely different painting, perhaps born out of accidental splashing. The knack is being able to spot these potentials that trigger the mind and be able to turn them into a painting. Somewhere in your subconscious lies the information – something seen, an old sketchbook or whatever.'

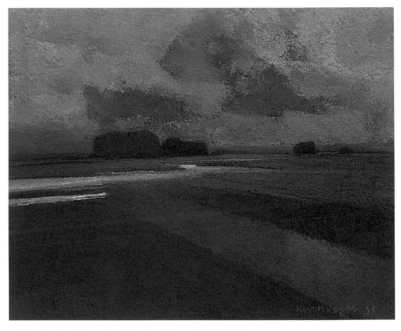

Saltmarsh Creek pastel on paper **30 x 25cm**
This simple but effective composition captures the vast emptiness of the salt marshes but also its drama in the right light. Notice how the lines of the marshland draw us in from the bottom-right corner to the silvery white streak of river in the centre of the picture. Natural effects like this can be enhanced or even invented to direct the viewer to the focal points.

Keith starts by dividing his support into thirds and then into halves or quarters. He positions the horizon somewhere between the half mark and the upper or lower third division. In this case he chose the higher position to give him the space required to render the complicated forms of the landscape.

Keith has positioned the viewpoint so that the river forms a dramatic diagonal from the lower left-hand corner which leads us into the centre of the picture. This injects considerable energy but it is slowed somewhat by the subsequent zigzag of the river's course which produces a slower, more rhythmical movement, giving us time to look about. Notice how our eyes keep returning to the river only to be drawn back into the painting.

Most of the 'activity' in the painting occurs in the middle of the support between the halfway point and the horizon line. To balance this Keith puts lots of work into the sky and foreground. This ensures that our eyes have plenty to look at in every area of the composition and we are not left statically focusing on a central plane.

golden rule

Using a picture mount

Keith likes to have a picture mount with him while he works which he can place over the picture part way through the painting process. This helps to take him one step back from the image and give him a better overview. He also finds that if he moves the mount about a bit he can identify other compositions which might work better. 'For me it is important to have a picture mount to put over the painting while I am working on it. You see where the painting is going, areas that need developing, the general balance of the picture and, more importantly, how the composition is working. I often find myself changing the composition midway, the mount helping to identify a better composition than perhaps I originally intended.'

Colour

Pastel colours should ideally be stored in the special pastel boxes which have foam dividers because if they are all jumbled up together they will very soon take on the same coating of murky grey and be difficult to distinguish. Keith stores his large collection of pastels in trays that are divided up in a similar way to an oil palette: 'yellows, reds, browns/umbers, blues and violet/purple with greys intermixed. I try to keep them in a tonal order, light to dark, but at the end of a painting session the trays are pretty mixed up.'

The artist's palette

'I use a variety of pastel brands. I started with Daler-Rowney's 24 colour landscape box and gradually added to it. Sennelier has a wonderful blue-black-indigo range and I also like Unison's earth yellows, greys and browns. For detailed drawing I use Conté hard pastels. I find the Daler-Rowney blues and cool greys are very important at the start of a painting – I use them as a tonal guide. Blocking in and juxtaposing other colours and tones, washing over the pastel with a solution of pumice powder, gum Arabic and water and leaving to dry can give an interesting effect and surface to work on.'

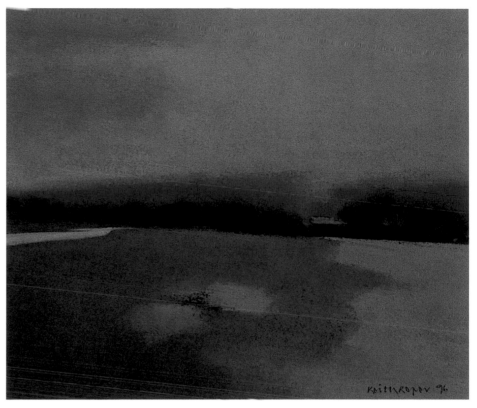

Sand Hills, Saltfleet pastel on paper **30 x 25cm**
The temptation with pastel is often to get busy with pattern and colour, but this incredibly versatile medium doesn't have to be used only like a drawing medium in short, intermingled strokes. Here, for example, you can see what can be done when it is used in great sweeps or washes. The very limited colour scheme creates a wonderfully moody atmosphere which is enhanced by the way the colours merge. This is a contemplative painting.

pointer

Using pastel in a painterly way
Pastel is usually classed as a drawing medium simply because it comes in stick form, but this is to underestimate it. Students who try it for the first time very soon realise that because it can be smudged, blended and wiped off it can be moulded in a very three-dimensional way (and the same is true of charcoal). You can work from within the body of a form, moving out towards the contours, just as you can with paint, rather than starting with the outlines as you would in a drawing and then filling in. Used in this way, often with the side of the pastel rather than the tip, pastel is most definitely a painting medium.

Technique

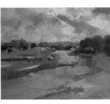

'I work on Waterford or Arches 300gsm HP watercolour paper, stretching it on a drawing board so that if the painting is not working out I can wash it all off, leave it to dry, still stretched, and start again. I start with a loose wash of gouache paint, blocking in the basic areas – sky, land, mud flats and so on. Then, when this is dry, I apply a solution of pumice powder, gum Arabic and water over the whole painting and again leave it to dry thoroughly. This gives the paper a tooth for the pastel to grip – I don't like manufactured pastel paper.

'Now I can start to apply the pastels, working lightly and loosely and spraying with fixative. (I particularly like Winsor & Newton fixative which causes no discolouring and leaves a nice gritty texture.) The beauty of pastels, though a bit messy, is that they do not need any drying time. As soon as the painting is finished it must be framed or stored to avoid the surface being smudged or spilt on.'

shortcuts

Mixing pastel with other media
Soft pastels combine remarkably well with other painting media, enabling you to create an even wider range of effects. It is quite popular to combine it with watercolour, acrylic or gouache, most often applying the water-based medium first with the pastel on top, although more of the water-based medium can be added later, if desired. Pastel can also be softened with water – simply apply the pastel and then wash over it with a brush dipped in clean water. Alternatively, try using turpentine which can be applied in the same manner. Apply more pastel on top when the turpentine is dry or nearly so. (If you work over damp colour it creates a lovely dappled effect.) Be careful, though, that your paper is suitable because water can dissolve the glue used to adhere the textured element of the support – on pastel card, for example.

Looking closely you can see that Keith allows some of the gouache underlayer to show through, offering an alternative texture. Gouache dries to a soft, slightly powdery consistency which blends very well with pastel.

Bold sweeps of creamy pastel are applied over the blue of the sky, sometimes densely, sometimes lightly for a broken-colour effect. This helps to create different textures, colours and qualities in the sky which enliven it and give it a wonderful freshness.

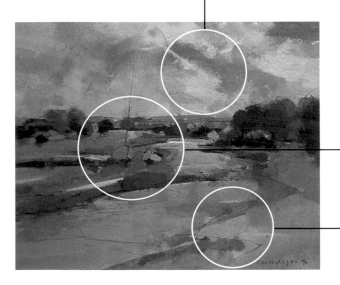

Where the colour is thinner, as here, we are allowed to glimpse the construction of the painting, with light pencil marks showing through. Most amateurs like to remove all traces of their working methods, but the more experienced artist has the confidence to leave such marks which can add considerable interest to the finished piece.

SEASCAPES PASTELS

Margaret Glass is attracted to water as a subject because it shows lighting effects at their best. 'I am drawn to a subject by the light that is in it or on it – the light of the dawn or a setting sun, the heat of midday with its short dark shadows. The inspiring thing about it all is the light and the challenge of how to capture it and make it sing.' Water is the ideal subject or background for any artist who is fascinated by light, because its reflectiveness means that light becomes particularly magical here. 'Light is reflected by water so I enjoy most marine subjects. I live near the east coast and have the rivers Alde, Deben and Orwell close by and this has played a large part in my becoming an artist.'

Low Tide, Woodbridge by Margaret Glass pastel on paper **30 x 41cm**

'To be simple is not always as easy as it seems.'
(Ferdinand Hodler 1853–1918)

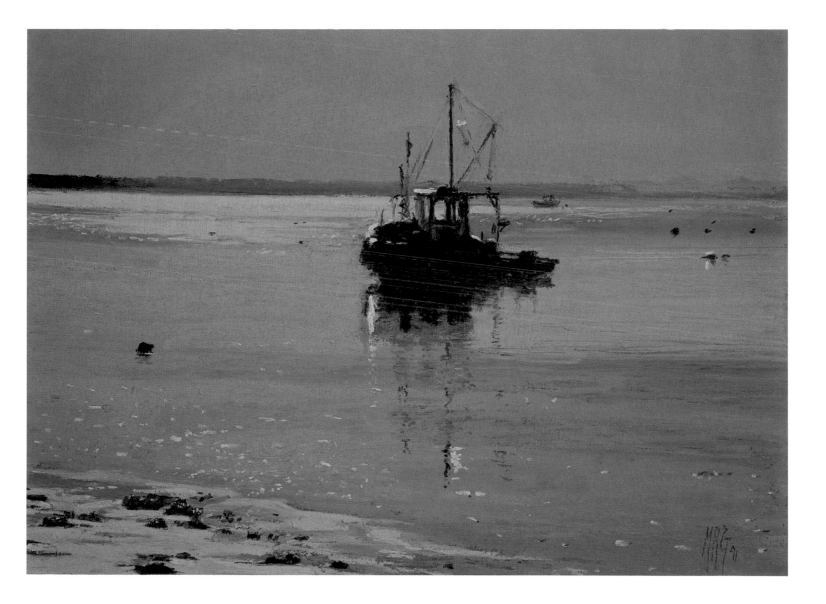

Composition

Margaret doesn't make preliminary sketches. She is one of the many artists who like to pour their impressions and gut feelings straight onto the paper, so she paints either with her subject before her or from photographic references in her studio. Some artists find that working with sketches helps an idea evolve and develop but to the more emotional or impatient artist sketches act like a black hole, sucking in their ideas and inspiration and leaving nothing for the painting itself.

The emotional response to a scene has much to do with the composition in Margaret's work. In 'Low Tide, Woodbridge', for example, she wanted to express her pleasure at the silence of this scene, 'with the only sound being the draining mud. You can hear it drain away and as it does so it reflects the light in different ways.' Because it was the silence and the light and not the boat that Margaret was concerned with, the boat is depicted relatively small so that we can feel the silence that pervades the emptiness around it.

Shared Secrets pastel on paper **41 x 30cm**
In this very different composition Margaret moves in close to her subjects to give a sense of intimacy. The two girls are deep in conversation and both looking down, possibly because they are discussing the kind of personal subject which it is easier to talk about without eye contact. 'Somehow the energy in the breaking waves and strong wind gave an even stronger sense of heartfelt secrets being shared as there is no danger here of their words being carried to other ears. They are quiet together in their intimacy while all around is the thunder of waves and wind.'

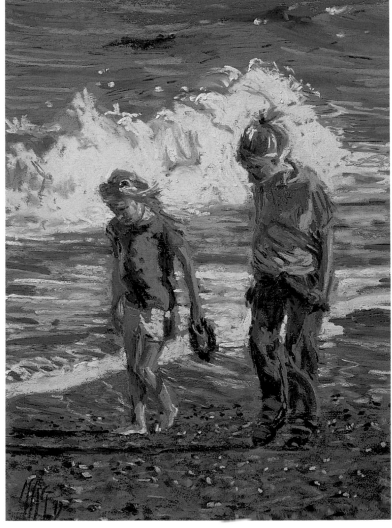

golden rule

Placing the subject centrally

The centre of the support is a popular position for the subject of a painting because this is where the viewer looks first and it seems natural to place it with an equal border on all sides. This position is particularly suited to a portrait or where you want to create a sense of calm, because it is a very stable, static and even heroic position. However, most artists avoid placing the subject in the absolute dead centre of the support because it can look rather contrived. It is better to place it near the centre. Here, Margaret has placed the boat slightly above and to the right of the centre point to avoid this effect. Notice that the boat is pointing to the left, leading into the picture and its reflection on the sand points down, anchoring it to the centre more firmly.

Margaret places the horizon very high in the painting, nearly three-quarters of the way up from the bottom to give maximum space to the wet mud and water. This allows plenty of space to depict the silence of the place.

A small figure in a large landscape can often be used to express solitude or the insignificance of Man. Here Margaret uses the fishing boat in the same way, and because it is inanimate on the wet mud, it adds to the sense of total calm. Its position in the centre of the support increases this feeling – this is the first place we look in a painting and if we find the subject here it seems to confirm the order of things and all seems right and stable.

The distant boat in deeper water is quite significant. It links 'our' boat with the rest of the world to prevent the silence and remoteness of our position from becoming too extreme. Notice how it is strategically placed in our field of view when we look at the near boat so that we can't miss it. Also, because our eyes don't have to travel too far to reach it there is no great sense of movement to disturb the peace.

Colour

Pastel is unlike any of the mainstream painting media because you can't mix the colours to make more so you have to start with a much larger selection. Seven paints is plenty for oil or watercolour, for example, but with pastel you can't achieve much with less than about 20, and really the more you have to choose from the better. For the artist just starting out a box set offers a good basis, but again, the larger the box the more useful you will find it. Margaret has literally hundreds of colours and although she will only use a small proportion in each painting the choice is necessary to get the balance just right. Her huge range of colours is also vital for the way she uses them – in a very painterly way rather than as a drawing medium. She covers the whole ground with colour, using her vast selection to develop subtle changes in tone – 'Low Tide, Woodbridge' could easily be mistaken for an oil painting.

The artist's palette

Margaret works mainly with Sennelier pastels – 'I have the whole range of 560 or so tints. They are buttery and soft and there is a good assortment of strong, clear darks. I also use the Schminke range of greys which are as good and as strong as the Sennelier pastels.'

Too many colours in a painting can ring a discordant note, so Margaret is careful when she selects what to use for a particular painting. She finds it helps to 'choose a warm and a cool of each tint in the same tonal range.' This also enables her to reproduce the effects of aerial perspective, a natural phenomenon which makes colours look cooler and more muted the further away they are.

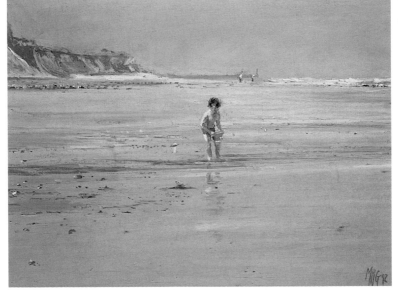

The Green Bucket pastel on paper
As in much of Margaret's work the colour selection here looks deceptively simple. The pale blue of the sky is reflected in the water and the pale beige of the sand is repeated in the dunes or cliffs. Look closely at the foreground area, however, and you will see that there are subtle colour variations which give the water its realism. Notice that the only slight discord is centred on the child – the rather acidic blue-green of the bucket, the ultramarine on the shorts and the pink on the body. This helps to draw our attention to this central figure.

pointer

Pastel colour ranges

You can't mix pastels to create graded tones although a certain amount can be achieved by overlaying broken colour, so that the lower colours shine through, or by blending. Instead the manufacturers do the mixing for you, producing ranges of related colours with light to dark tones and warm to cool. When you are starting out try to keep the labels with each stick so that you can categorise it. This will help you match colours from the same family which go well together – a dark yellow-green and a pale yellow-green, for example. Margaret always works with a warm and cool version of each colour in the same tone – in a black-and-white picture they would look the same, but in colour one advances (warm) while the other recedes (cool). This enables Margaret to create depth in the painting while at the same time retaining a unifying colour harmony.

Technique

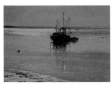

Margaret usually works on glass paper (sandpaper) without making any preliminary sketches. 'I have developed my technique on the basis of using glass paper. It grabs the fine particles of pastel and allows a build-up of many layers of pastel if needed without filling the tooth of the paper.' She needs a paper with sufficient tooth because she works with pastel not as a drawing medium but as a painting medium. Instead of sketching out the scene with the tip of the pastel and then methodically filling in, she works with blocks, streaks and smears of colour. 'I have always thought of pastel as a painting medium. Rather than colour and line in one, I see the pastel tints as capable of being a body of opaque colour that can be applied as a wash and I use it accordingly.'

'In painting, as in the other arts, there's not a single process, no matter how insignificant, which can be reasonably made into a formula.'

(Pierre Auguste Renoir 1841–1919)

shortcuts

Pastel papers

Pastels can be used on just about any paper or card, and what you choose is really a matter of economics, personal taste and style. The smoother the paper, the less you can build up colour depth, so flat typing paper would only be suitable for brief sketches, for example. At the opposite end of the scale are the more expensive glass papers and pastel cards which have a noticeable tooth and which enable you to apply layer upon layer of pastel for highly detailed, professional results. These more textured surfaces wear down the pastels quite quickly. In between is a whole gamut of different surfaces. Try cardboard, which is particularly good if you like to create washes by going over the pastel with water or turpentine, or you can even use ordinary DIY sandpaper. You can also buy velour or velvet papers which take a lot of pastel and have a lovely silky finish. The choice is yours, so sample a few and see what best suits your style and pocket.

Notice the subtle variations of texture which help to add form.
Whereas the sky and wet sand have been blended smooth,
Margaret applies the pastel more thickly and generously in the
deeper water and for the foreground, (below), to suggest the
greater texture here. This also provides a pleasant contrast to
the smooth areas to give our eyes
more of a visual feast.

Notice the careful, minimal
use of highlights on the boat.
It is always tempting to get
carried away with juicy bits
like this and overdo it but
Margaret used a restrained
hand to describe the play of
light perfectly and to reveal
her own love of the subject.

The sky and wet sand
appear to be much of
a muchness in terms
of colour, but look
closely and you will
see the subtle
differences which give
them life and depth.
To a great extent it is
the subtlety of colour
blending which gives
Margaret's work its
painterly quality.

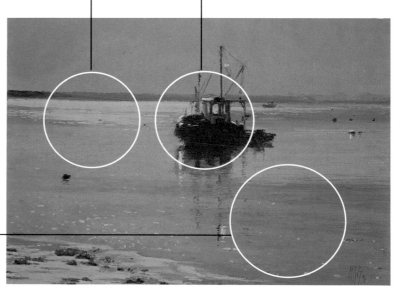

mixed
media

SEASCAPES MIXED MEDIA

Linda Norris, who painted this dramatic seascape, has an intense artistic drive which eventually led her to move home, setting up in Pembrokeshire, 'for the dramatic possibilities of the light and the sense of being on the edge, between sky, rock and sea.' Her work is now firmly rooted in the Welsh landscape yet her ability to capture the intense emotions of Nature, from angry seas to still waters, gives her work a universality which mesmerises people who have never even been anywhere near Wales.

Linda's work is about the essence of a place rather than its exact physiognomy – 'I try to express the feeling of a particular place and time, rather than capturing the specific geographical details of the location. When I first moved to Pembrokeshire I spent several years painting outside direct from nature, familiarising myself with the place. Now I spend a lot of time outside, walking the coast path, getting my inspiration. Any sketches I make are an aid to the process of experiencing the landscape rather than working drawings for painting. The source of my inspiration can just as well come from turning a corner in the road on the way to my studio, or glancing at the sky when I'm filling the car with petrol as from time spent outside specifically gathering ideas.'

Winter Shore by Linda Norris mixed media on paper **20 x 20cm**

'My work is always somewhere between abstraction and figuration.'

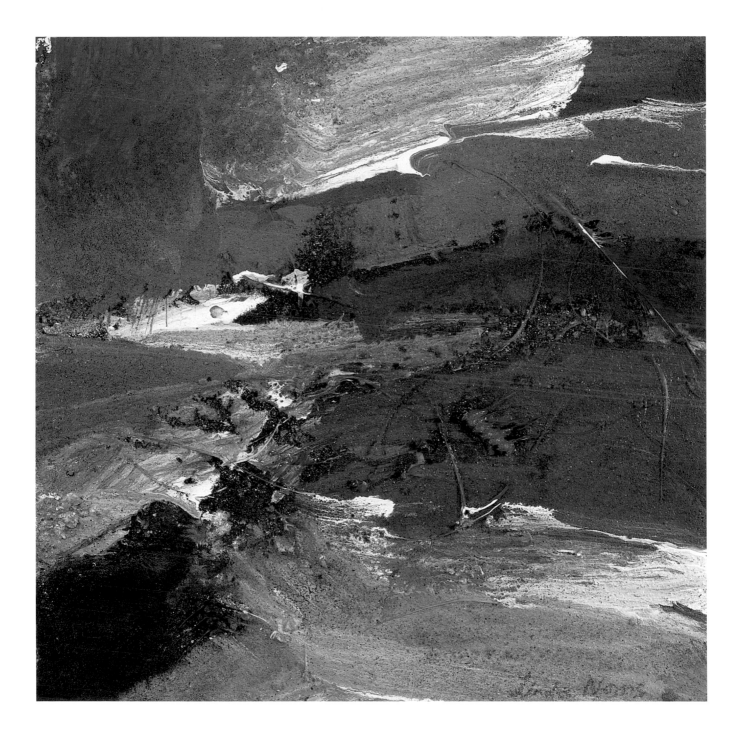

Composition

'"Winter Shore" is a painting inspired by a trip to Shetland. The dramatic feeling of the sky meeting the shore there, where the sea turbulently greets the first land for hundreds of miles, was the inspiration for this painting. I used sand, fish bones and other detritus gathered from Shetland in the work. There is a sense of all the elements coming together, not divided by a horizon or a shoreline, an overall feeling of movement in the work. The composition evolves in the struggle to make sense of the feelings of the place and in the effort to express something of the elemental force of the landscape.'

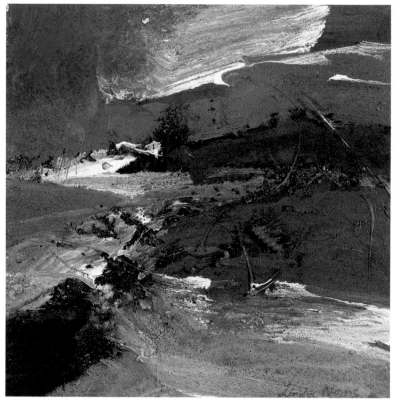

'... It is the light
Between the mirrors
Of the sea and the sky
Suspended.
In a world, in-between,
Of mirrored images.'

(by Rotraut Russig on seeing Linda's work)

Wet Sands mixed media on paper **35 x 35cm**

This painting sets a marked contrast with 'Winter Shore'. Not only are the colours greyed and muted to set a quieter note, but we see the calming line of the horizon which is reinforced by the horizontal strokes used to establish the sea and shallow waters. However, all is not as tranquil as it first appears. The menacing grey clouds and their reflections in the wet sand provide a build-up of energy augmented by the energy with which they have been painted. The landscape is about to change once more.

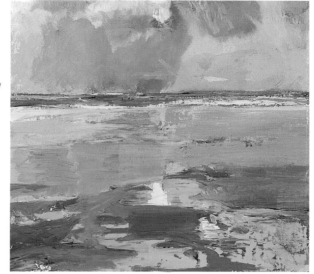

On first impressions 'Winter Shore' has no obviously straightforward compositional form. However, this is not detrimental but indeed gives impact and meaning to the work. It provides a fluidity which aids in the expression of the life and movement of the sea. The potential danger with this device is that we won't be able to find our way into and around the image so Linda draws us in along the crest of a wave which runs on the diagonal from the bottom-left to top-right corner.

Blocks of colour sweep in from each side of the support and smash together in the centre with the movement and vigour of clashing symbols yet at the same time the colours intermesh like fingers interlinked. This is the dichotomy of the sea – it is one body of the same substance yet under the influence of wind and moon it seems to war even with itself.

Two bold zigzags, one in black or near-black and the other in white rip up and down the support to intensify the power and energy of the image. One might expect lines in these extremes of colour to cleave the image in two, but because they are uneven, broken lines and they blend into neighbouring colours, they give vigour without divisiveness.

golden rule

Diagonals for energy

Horizontals and verticals are known to produce a calm feel in compositions while slanting angles create energy and movement; the sharper the angle, the more energy it conveys. In 'Winter Shore' blocks of colour drive in from the sides, all set at slightly different angles to create an exciting conflict between more sedate movements and energetic, forceful ones. This struggle reflects the varying energies of the sea and indeed of life.

Colour

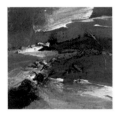

For Linda colour is often the starting point for a painting – 'I start by mixing a range of colours which relate to the mood I want to express in the work. The colours of the landscape here can be startlingly dramatic and change in an instant; I want my work to reflect that sense of movement and surprise. In "Foxglove Seas", for example, the startling contrast between the pinks of the foxgloves and the greens of the background reflect my surprise in finding such stunning pink among the greys and greens of the coast path.'

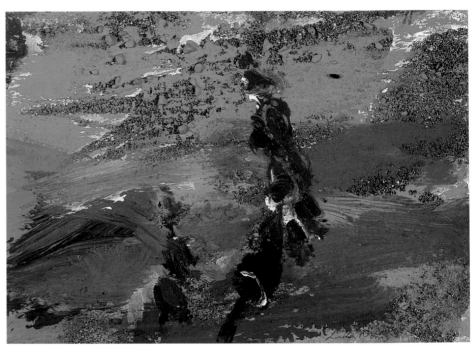

Foxglove Seas mixed media on paper **20 x 15cm**

The artist's palette

Linda used water-based paints for the pictures shown on these pages, supplemented with shore sand to give it extra body and a certain reality. 'I use artists' quality acrylics made by Winsor & Newton, Liquitex and Rembrandt, avoiding any colours which have a tendency to fade. For these paintings I would have used titanium white, lemon yellow, yellow ochre, alizarin crimson, magenta, phthalo turquoise, French ultramarine, cobalt blue, burnt sienna, burnt umber and Payne's grey. I also sometimes use metallics – Rembrandt metallic acrylic paint, gold leaf and Sennelier metallic oil paint sticks. I am careful about using metals because they can oxidise, and some have to be sealed to prevent this. When I'm not sure about something, I consult Ralph Mayer's "The Artist's Handbook of Materials and Techniques".'

lemon yellow | yellow ochre | alizarin crimson | magenta | phthalo turquoise

French ultramarine | cobalt blue | burnt sienna | burnt umber | Payne's grey

lemon yellow | cobalt blue | lemon yellow | phthalo turquoise | magenta | French ultramarine

pointer

Mixing brands of paint

Linda uses paints from three different brands – Winsor & Newton, Liquitex and Rembrandt. Most manufacturers would recommend that you only use one type in a painting because each has different textures and handling, but once you get to know your paints you can combine them, taking advantage of the qualities of each. For example, Winsor & Newton's Finity paint is thick and buttery while their Galeria Flow Formula is very liquid and designed to retain brush marks. Liquitex High Viscosity paint falls somewhere in the middle, offering good covering power with a smooth, easy-to-blend texture rather like oils. Meanwhile, Rembrandt acrylic is a good all-rounder, designed to retain brushmarks yet with strong covering power.

Technique

'When I was at college I learned to paint in a very tight, figurative way – painting from life from a fixed viewpoint with one eye. The discipline of this way of working gave me a good foundation for developing my own techniques later on. I now work in a much more fluid way, but I am still methodical in my approach – I lay out my palette before I begin work and I mix each colour precisely and cleanly before applying it.

'My technique changes depending on what I am trying to achieve. Often my work is very textured; in addition to pigments and metals, I utilise sand and grasses, stones and feathers found in the landscape. These I mix in with the paint using acrylic medium. I paint with brushes (especially household decorating ones), painting knives, palette knives and kitchen knives – whatever seems appropriate at the time for the work I am trying to do. I also sometimes sand the paint back down to the paper or scrape it right back, and sometimes I make the paper itself using cotton linters and incorporating things from the beach and shore in the actual paper.'

shortcuts

Utilising natural materials

Linda often utilises natural materials in her work, either adding them to the paper when making it herself or applying them on top. If you wish to follow suit start to become aware of suitable items as you travel through life. It may be pasta from the kitchen cupboard, packaging you were about to discard, a dried leaf found on a walk or any other item that later becomes the ideal piece to represent an element in a painting. Obviously it is more meaningful to collect from the location you are painting but this is not always either possible or practical. When you come to apply your find(s) use a suitably strong glue and make sure it will not react badly with the paint that you are using.

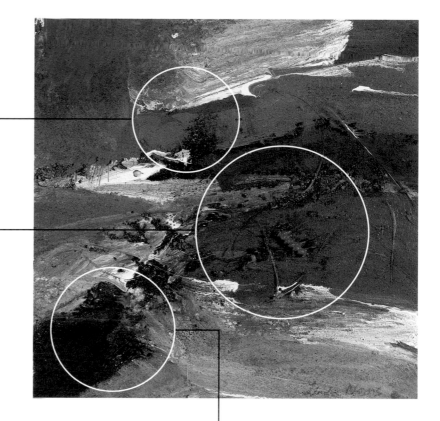

All Linda's paintings are worked in her studio from memory because the most important thing for her is getting down the emotions aroused by a particular scene or an empathy, a feeling of oneness, that she felt for it. The heightened emotion aroused by Linda's visit to Shetland is reflected in the extreme contrast of colour.

Thick rivers of paint help to capture the ebb and flow of the water and aid the painting process; by applying the paint in thick, liquid form which emulates the texture of the sea Linda is able to touch the sea with her mind and even merge with it, sensing its being.

Linda used fish bones and sand to add texture and beef up the excitement of the picture surface. The fact that these items were gathered from the location gives added meaning.

SEASCAPES MIXED MEDIA

Ray Balkwill describes painting estuaries and seascapes as 'a joy, an escape from the bustle of a modern world, and the mere thought gets me reaching for my brushes. For me it is the ever-changing light and colour, its reflections, fishing boats, wet mud, rusting chains, wooded creeks – a thousand things to stir the imagination. It's not only a visual feast, either, the sound of lapping water, the "popping" mud on a falling tide, the calling gulls, the smell of the seaweed. All this makes it one of the most satisfying subjects to paint.'

Ray tries to capture some of these sensations in his work. 'When painting my main objectives are to capture mood, atmosphere and a sense of place – to convey feelings rather than just images. I am a strong advocate of painting *en plein air* and hope that my work is imbued with the results of exposure to the elements, presenting a sense of spontaneity and vitality. One cannot wait around for inspiration to come along, and if you are prepared to experiment and widen your creative horizons you will soon gain both confidence and skill.'

Sunlit Creek, Porth Navis, Cornwall by Ray Balkwill mixed media on paper **35.5 x 54.6cm**

'One cannot wait around for inspiration to come along.'

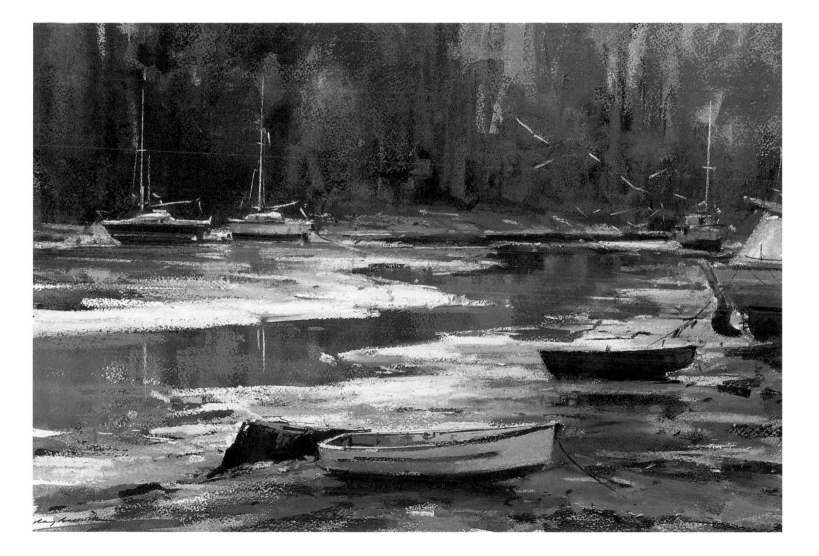

Composition

Ray always begins by making sketches. He stresses that 'there are no shortcuts to successful painting; sketching and recording in situ as often as possible is vital.' Since weather, the tide and light can change quickly Ray aims to complete a sketch within 15 minutes. 'If the scene changes I then have my sketch to fall back on.' He often works his sketches in willow charcoal combined with Conté crayon and marker pen. He finds willow charcoal ideal because it is so responsive and perfect for working quickly. 'The tonal values can be stated or changed with the rub of a finger or by lifting out with a putty rubber, and the subtle marks and range of tones you can achieve are endless.'

His monochrome sketches are invaluable. For a start they simplify the scene – 'seeing the landscape in terms of a few broad patterns of varying tones is extremely useful.' They also help Ray sort out compositional priorities such as centre of interest, balance and tone, all 'vital components of a successful painting'.

golden rule

Clarifying the tones

When there is a lot going on in a scene, as in 'Old Mill Creek', it can often be difficult to distinguish the tonal differences. A good way of bringing out the important tones is to squint at the scene. This knocks out the subtlest tonal changes, enhancing the major differences to make the main tonal blocks a lot clearer. Ray also finds that this process helps him decide what to put into a painting and what to leave out by clarifying how well the balance of tones and shapes works. For example, 'I often turn boats around and group them closer together or sometimes even leave them out completely.'

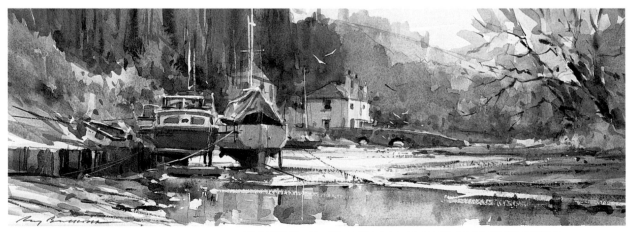

Old Mill Creek, River Dart mixed media on paper **37 x 13cm**
'I could have worked this painting in any of a number of formats but being quite a busy subject I decided that more of the trees and bank would help the composition in focusing on the boats and mill.' This very short, wide panoramic format not only works very well with the subject but is instantly eye-catching because it is so unusual.

Ray uses the line of the far bank as the horizon, roughly a third of the way down from the top of the support. Because this line is soft and does not extend right across the support it gives the image a very relaxed feel and our eyes are encouraged to sway across the scene.

For this sketch of 'Creek, River Hel', Ray used a Rexel-Derwent water-soluble pencil in indigo (below). Brushing water over the pencil turned his drawing into a watercolour, enabling him to plot a range of tones. He finds this very helpful for exploring tonal relationships and mood. Notice how Ray has simplified the scene yet caught all the essential elements: the strongest and lightest tones and the positions of the focal boats and river inlet. His sketch enables him to see how well the composition works and he can adjust it for the final painting if necessary.

The soft zigzag of the creek leads us deep into the picture from left to right. When we are being led along a 'path' like this, it is always satisfactory to find something at the end, and here we are not disappointed because we find a sailing boat (picked out in eye-catching red and white) and a flock of gulls highlighted by the darkness behind them.

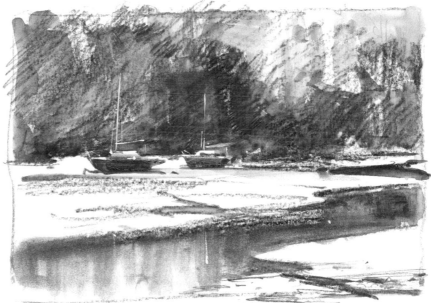

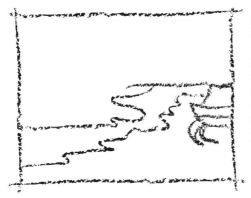

Notice how Ray has included the tip of a boat peeping in on the right-hand side of the image. Most novices avoid cropping because they feel they must show all or nothing but including part of an element can have very positive effects, creating a sense of intrigue, hinting at more beyond the confines of the picture and sometimes producing a sense of movement.

Mixed Media 97

Colour

'Don't rush into colour too soon. Aim to produce lots of sketches and remember that sound draughtsmanship and keen observation is the key to your painting.' Ray knows the importance of tone in creating a realistic and convincing image, so his sketches not only set down the linear framework but resolve the tonal positions and balance too. Colour comes next, and only a light touch is required because the bones of the picture are fundamentally sound.

The artist's palette

Ray starts his watercolour and pastel work with a drawing and then applies the watercolour. For 'Sunlit Creek' he used a limited palette of cadmium orange, phthalo blue, raw sienna, burnt sienna and burnt umber. With the exception of cadmium orange these are all transparent colours so they work well together to produce some wonderfully sheer washes while cadmium orange adds brilliance and forms a link with the vivacity and opacity of the pastels which will be laid on top. Ray mainly uses Unison pastels which are particularly rich and soft, again using a limited palette of just 15 colours – a fairly small range for pastel work. Ray points out that it is easy to get carried away by the colours available in pastel, confusing and overcrowding the image. His tip is to keep the colours you are using separate from those in the main box which helps you keep an eye on exactly how many you are using.

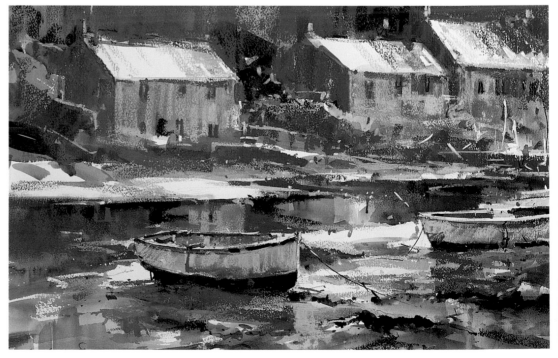

Peaceful Afternoon, Noss Mayo
mixed media on paper **35.5 x 53.5cm**
Colour is very important in this painting in setting the mood. As in 'Sunlit Creek' Ray has used a limited palette but the colours here are warmer, with a wonderfully balmy olive green used both in the bushes and on the mud flats. The uplifting combination of the green with greys, creams, browns and blues captures all the cheeriness of a sunny afternoon by the water. (Notice that most of this accent colour is provided by the pastels, while the structural details have already been put in with watercolour and ink.)

blue-violet 16

yellow-green earth 4

additional colour 32

yellow-green earth 6

blue-violet 10

yellow-green earth 11

blue-violet 1

green 17

red earth 1

brown earth 3

red earth 3

yellow-green earth 13

brown earth 10

brown earth 6

cadmium orange burnt sienna

burnt sienna raw sienna

phthalo blue burnt sienna

pointer

Using transparent colours

Although all watercolours have a certain degree of transparency some have better covering power than others and knowing which is which will enable you to use your paints to best advantage, choosing opaque colours to make amendments, for example, or selecting transparent hues to build up a rich depth of colour. You may have noticed that some of the artists in this book use both raw sienna and yellow ochre, two very similar colours. The difference is that yellow ochre is opaque while raw sienna is transparent, so having both available enables the artist to choose the best one for the job. Other transparent colours include Winsor lemon, Indian yellow, Winsor red, rose madder, alizarin crimson, cobalt violet, magenta, cobalt blue, French ultramarine, Prussian blue, viridian, the siennas and umbers.

cadmium orange

phthalo blue

raw sienna

burnt sienna

burnt umber

> '**Paint generously and unhesitatingly, for it is better not to lose the first impression.**'
> (Camille Pissarro 1830–1903)

Technique

'Painting thrives where there is a sense of adventure, and risk taking is something I encourage. For me painting is all about the directness of approach and a bravura technique. Creating a sense of movement and energy is my main aim, and working quickly from Nature helps to create that excitement. However, it must be backed up by keen observation and sound drawing from which the ideas will soon follow.

'For many years I have worked on marine subjects solely in watercolour until more recently when I decided to experiment combining watercolour and pastel together in the same painting. Pure watercolour is more demanding and planning is essential, particularly in reserving the white of the paper, as in "Old Mill Creek". With pastel, being able to go straight to a colour without having to mix it saves valuable time. It is also much easier to correct mistakes with pastel.'

Ray began 'Sunlit Creek' by stretching a half imperial sheet of Bockingford watercolour paper onto board. Then he sketched in the composition with a black permanent marker. 'For the foundation of the painting I used watercolour and a diluted black waterproof drawing ink. I reserved the white of the paper for the glistening mud with masking fluid. I stood at my easel with the board tilted at a slight angle and applied the paint with a 2.5cm hake brush. Once the washes were completely dry I removed the masking fluid and began the pastel stage using the sticks on their sides in a direct way.'

The sparkling effect often seen in Ray's paintings is partly due to his technique but also to the site he chooses for his viewpoint. 'I like to paint *contre-jour* (against the light) which simplifies the masses and produces a more dramatic effect. In "Sunlit Creek" it was the strong contrast between the sparkling highlights and deep shadows, as well as the variety of colour in the wet mud which really excited me.'

shortcuts

How to avoid overworking

Overworking is a problem with all media but perhaps particularly with pastel because too much will clog the paper and it is so tempting to use an excess of colours. Ray finds that it is better to lift off colour if you make a mistake, rather than continually adding more. He also recommends leaving well alone. 'Paintings are often ruined at the last hurdle, particularly if they are finished back in the studio. That early spontaneity and excitement can be lost, so be warned. Picture making is about enjoying the painting experience and exploring all its possibilities, experimenting and taking risks – and learning from them.'

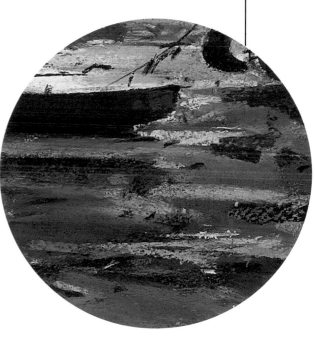

Bold vertical strokes of pastel, left mainly unblended, create the look of the undergrowth in the background. The overlying strokes create sufficient interest to produce a lively effect but the lack of detail ensures that we focus on the main areas of interest – the boats and the waterway.

In accordance with the rules of aerial perspective Ray uses bolder, brighter colours in the foreground to bring this area forward. Notice that the red of the boat in the background is dark, keeping it in its proper place. If it was a bold scarlet it might spring forward too much.

Soft strokes of partially blended pastel merge with the hue of the watercolour underneath to create a very convincing stretch of water. A few light strokes for the reflections of masts and some dark shadows complete the effect.

SEASCAPES MIXED MEDIA

Mike Bernard believes that he was drawn to the sea as a subject simply because of its proximity in his youth – he was born and bred near Dover in Kent. 'I became interested in drawing and painting Dover Harbour and other local seaside locations like Deal, Kingsdown and Whitstable when I started studying for my 'A' level Art at school. I was attracted not especially by the open space of the sea but by the activities and structures in and around it – fishing boats, piers, harbour walls, beaches, figures, fishing huts, nets, ropes and so on.

'When I moved away to Surrey to go to art school I more or less gave up seascapes to concentrate on landscapes but the interest in seascapes began once more with a series on Portsmouth Harbour and was reinforced through visits to the coasts of Somerset and Devon. My "discovery" of Cornwall has been my most inspired moment. I was knocked out by the wonderful patterns created by the clusters of fisherman's cottages and fishing boats and the textures of the sea walls, fishing nets and rusty chains. All these images fitted in well with my growing interest in painting in a semi-abstract manner.'

Red Abstract by Mike Bernard mixed media on paper **37 x 30cm**

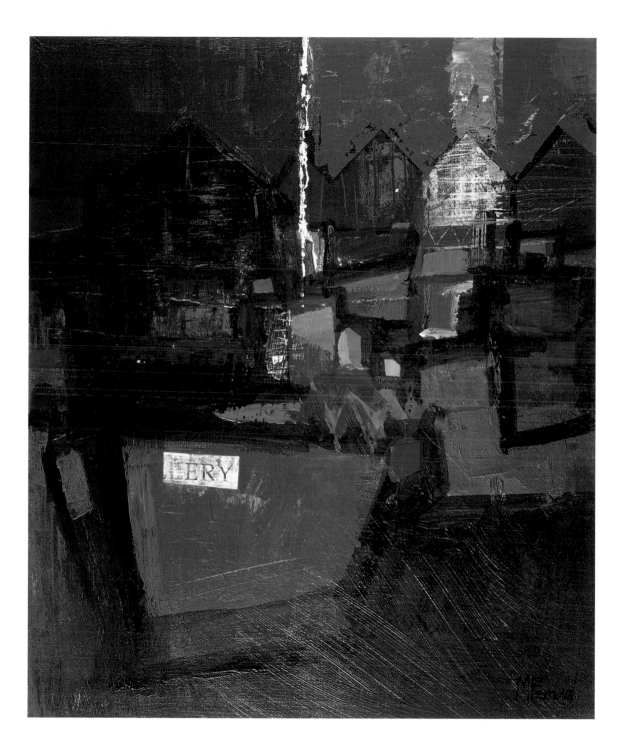

Composition

Mike nearly always works from brief sketchbook drawings. 'I don't like using photographs, though I always take many rolls of film as I have this fear that my subject will disappear overnight and I would then not have any record of the place. (It once did happen when I was drawing a street of old houses and the next day the whole street was demolished.)

'When I am preparing for an exhibition I go through all my sketchbooks and select drawings from which I would like to paint. I then make many thumbnail sketches so I can play with the compositions. I like to work within certain formats such as squares or narrow portrait or landscape formats. This always challenges me to come up with something dramatic. Quite often a new composition also becomes apparent when I have completed a painting and discover that one part of it has potential as another painting, perhaps in a different colour scheme.

'During certain periods of my painting year I have a desire to branch out in a more radical, abstract way. I like to develop some paintings so that the subject can almost be forgotten about and I can work with pure shapes and colours. I do this by taking a simple reference sketch and trying to flatten the image by rejecting the true form and space of the original. I start by drawing the image on the paper with a broad black line, letting the line "doodle" over the surface, mostly following the basic shapes of the subject. Other lines are allowed to create new, random abstract shapes. I then use a limited palette to fill the shapes, again with no attention to true form or space. I work freely, allowing myself to introduce decorative colours and marks, and sometimes using metallic colours.'

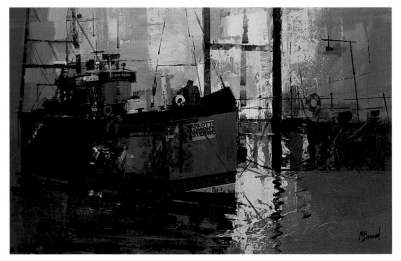

Green Fishing Boat mixed media on paper **53 x 33cm**
Mike's paintings present the world beside the sea not as the idealised vision that many artists like to depict, nor as an arena for specimen naval vessels as we see in many paintings from past ages, but as a working, modern, even industrial place. His modern materials of acrylics and collage, often with printed words still visible, as here, reinforce the vision, giving the paintings greater validity.

golden rule

Tone as a tool

Tonal patterns are as important in an image as the arrangement of forms but in most figurative work we hardly notice them because they are there through the graces of Nature. The artist can play with them a little, but not too much if he wants to retain the realism. In abstract and semi-abstract work the tones become simply another tool for the artist, like colour and shape. In 'Green Fishing Boat' the boat itself is presented as a dark to mid tone against light, imbuing the boat with greater power and substance. It's what directors do in horror movies to make something – or someone – more sinister. In 'Red Abstract', on the other hand, the boat is one of the lighter areas, emphasising the cheeriness of the red boat. The juxtaposition of extreme dark tones heightens the lighter areas still more and adds to the dynamism.

Where words appear in an image our eyes nearly always leap straight to them. Knowing this, Mike often places collaged words – or parts of words – where he wants us to look. Here, and in 'Green Fishing Boat', he puts them on the boats because these are the main subjects and he wants to draw our attention to them.

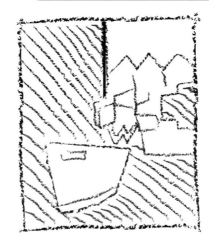

Tones play a more obvious part in abstract or near-abstract paintings than in figurative work. Here the lightest tones fall on a diagonal which includes the boat and the area of the huts in the top right – squint at the painting and you'll see them more clearly. This not only catches our attention but energises the painting because the movement of our eyes as we follow this diagonal is brisk and dynamic.

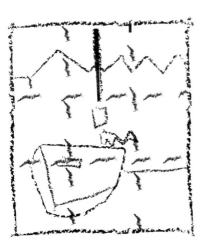

Most seascape artists follow the rule of thirds when placing horizontal dividing lines, such as the one between land and water or water and sky, roughly one third or two thirds of the way down the picture area. Mike mostly avoids this in his semi-abstract work, surprising and stimulating the viewer with the unexpected.

'I like to work within certain formats such as squares or narrow portrait or landscape formats. This always challenges me to come up with something dramatic.'

Colour

'I have very specific ideas about colour now. Previously I was trapped into thinking that I had to slavishly record the local colours but slowly I realised that I could be more in control. I now usually limit my palette, often choosing just two colours. These might be close on the colour wheel, such as blue and green or red and orange, or they might be complementary – blue and orange, for example. The limited palette gives unity to the painting and I can avoid the use of local colours which could create a disjointed feel.'

Mike's choice of colours – warm or cool – often suggest a certain time of day or a season, but this is something which evolves organically and isn't pre-planned, although obviously the choice between warm and cool colours does predispose a certain mood. 'I never start out with specific seasons, lighting or times of day in mind, but this usually evolves in the process of painting.'

Evening, Polperro mixed media on paper **66 x 51cm**
Mike often introduces a colour outside the main colour range to draw attention to a particular area. Here the palette revolves around red, orange and brown, but a flash of bright green on the red boat and again on the wharf, leaps out at us and demands attention.

The artist's palette

For 'Red Abstract' Mike used a palette revolving around red and violet for an analogous harmony (see Pointer, page 133). This creates a very congenial harmony although the high key colours also make it very strong. Mike used only Liquitex tube acrylics for 'Red Abstract' although he also sometimes uses liquid acrylics by Daler-Rowney (F. W. range) and Magic Colour. His palette for this painting comprised deep magenta, medium magenta, bright aqua green, iridescent copper, dioxazine purple, black and white. As he says, the use of the metallic colour further emphasises the unreality of the scene.

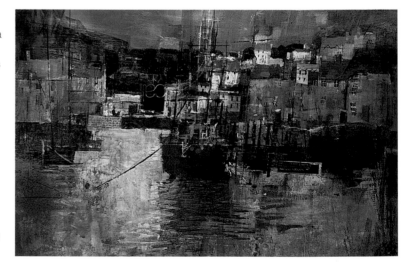

medium magenta deep magenta

deep magenta dioxazine purple

deep magenta

medium magenta

dioxazine purple

black

bright aqua green

iridescent copper

bright aqua green iridescent copper

pointer

About metallic paints

There are plenty of metallic colours available in acrylic –
Liquitex produces seven iridescent metallics in its artists'
colour range while Rembrandt produces four plus a number
of pearl colours, Daler-Rowney has six in its Cryla range
and Winsor & Newton has five in its Finity range. There are
also plenty more in the liquid acrylic ranges. These are fun
to use but artists should note that they are not designed to
be completely convincing. If you want a more realistic look
try powdered metallic paints, such as those by Roberson
which blend well with acrylics, or even opt for metallic leaf
which is easier to apply than you might think.

Technique

'My techniques have mostly been developed to enable me to paint in a freer, more expressive way, and most of my teaching career has been devoted to developing techniques and projects which allow my students to release their creative abilities in a bold and loose manner.

'I start most paintings with paper collage, newspaper, tissue, paper bags, envelopes and so on which help me create a textured abstract pattern which I can use as a springboard for the rest of the painting. I apply these with PVA glue or acrylic medium. Then I might use liquid acrylics, working wet-in-wet and encouraging random effects. The painting is usually in a state of confusion at this stage with the emphasis on creating interesting textural and colour effects. I often add white tube acrylic to enhance the texture, applying the paint with a lino printing roller, card, a toothbrush and sponges.

'The next stage is to bring out some defined images like the shape of rooftops which I might do by applying tube paint with the edge of scraps of card and I use pen and ink to add further selected details. Sometimes I add further collage to define the shapes of roofs, boats, figures and so on. Finally I add more pen and ink work and bring in the highlights with oil pastel. The resulting picture is hopefully a mix of some realistic passages together with textural and coloured abstract areas.'

shortcuts

Using card to apply paint

Using card scraps instead of a painting knife to apply paint is highly rewarding – it's fun to do and produces some excellent marks. You can load the edge of the card to produce linear marks such as masts or the edges of roofs and walls, or you can press down on it to smooth paint on as you would with a painting knife. The advantage of card over a painting knife is that not only is it cheap or even free, but you can cut it to shape for specific tasks and even cut notches into it to create additional textures. Start collecting scraps of different textures and thicknesses and see what you can do with it.

This mast has been created by applying white paint with the edge of a piece of card. The broken line this produces adds texture that can be used to suggest the play of light on an object.

Mike's free use of varied tools to apply the paint creates some wonderful textures which build on the textures already created by the collage. This adds a very definite third dimension to the painting, as well as emphasising the painting's role as a work of art, not simply a copy of the physical world.

Most of the collage underlayer has been covered with paint in this picture, but a few letters on the boat are still visible to attract our attention and intrigue us – what do they mean?

acrylic

SEASCAPES ACRYLIC

Inspiration comes to Elaine Pamphilon from the things around her – 'views through windows, shells, stones, plants, postcards, all of these can be used in paintings.' Like the majority of artists she is also inspired by the works of her fellows – her heroes are Alfred Wallis, William Scott, Ben Nicholson, Joan Eardley and Barbara Rae, to name but a few. Barbara Rae is a Scottish artist who 'paints vibrant and vigorous landscapes, sometimes on a huge scale. Seeing her work inspired me to paint bigger and bolder.'

St Ives, painted here, is something special – 'this place gets into your heart and soul', Elaine says. This particular work was a commission for Addenbrookes Hospital, Cambridge. 'I was invited to submit a book of photographs of previous work to a panel and also to look at the recently refurbished hospital foyer and reception area. We discussed what kind of work or images would fit the space, bearing in mind that it was a hospital and artwork chosen was to be somewhat tranquil and uplifting to staff and patients alike. I had no hesitation in suggesting a sea theme which would fit the colours of their interior – the walls were covered in white wood panelling with touches of pale sky blue and grey. The water would also convey the meditative and calm atmosphere that was wanted. Since the spaces were quite large we decided that at least two very large paintings would be required to make an impact.'

St Ives, Cornwall by Elaine Pamphilon mixed media on board **91 x 122cm**

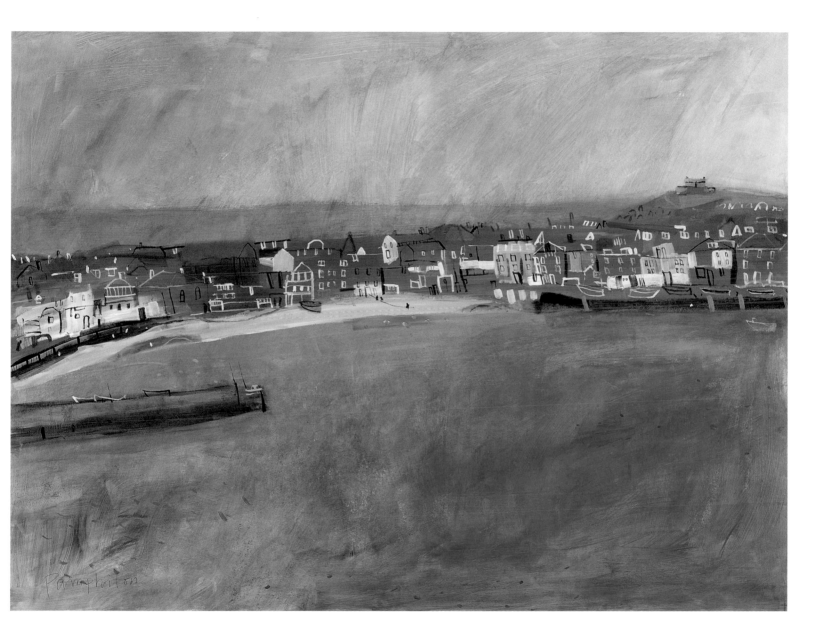

Composition

'When travelling by train or car I always have sketchbook, pens and pencils ready to jot down compositional ideas and colours in sky, landscape or buildings. What immediately appeals to me is combining ideas from several locations. I seldom use colour in this initial process but make detailed colour references all over the page. This comes easily when you know the range and brand of paint you're using and how it will respond, which colours go together and which can be placed alongside to give a lively and uplifting jump. It may not necessarily be what you are seeing, but it's how the place, time of day or weather are affecting how you are feeling about the subject.'

Elaine is following in the footsteps of the great tradition of artists in St Ives. Although not an abstract painter, she strives for loose treatments and effects, adhering to the motto 'if in doubt, leave it out'. She feels that 'the more sparse the composition, generally the more effective the painting', and recommends that artists 'home in on what you are seeing, on what really interests you – it may be the colour first, or a shape.'

Here you can see Elaine's preliminary work in her sketchbook, done purely in pen or pencil, showing no colour but with detailed colour notes. These notes can later be combined with the memory of the place and her feelings about it to produce a painting. Since she is working from brief visual notes, the painting is one step removed from the subject, but because her mind is uncluttered by the tiny details, she can work more with her emotions to produce a piece which is one step closer to the heart.

A surprising element to this composition is the high viewpoint – instead of placing the rows of houses on the horizon, as we might expect, Elaine allows us to see over them to the sea beyond. This reminds us of the context of the bay on the edge of the North Atlantic Ocean and it also links the top part of the composition to the bottom, encouraging us to make the leap over the houses to look at both sections.

Notice that Elaine does not use colour to help the scene recede or advance. Instead she uses it as a compositional device, leading us back and forth along the houses as we follow the warm browns, red, grey or white. A violet glow in the sky is reflected in the water in the bay, linking the two areas to encourage us to look from one to the other.

Cropping elements of a composition is a relatively new artistic device which was adopted more or less at the time when photography was introduced – Edgar Degas was one of the first to use it consciously. As in a photograph, a cropped subject can suggest movement or point to the world beyond this small keyhole view. By cropping the houses at both sides Elaine reminds us that there is more beyond the confines of the support.

golden rule

A painting for contemplation

'St Ives, Cornwall' was painted with a specific purpose in mind – to brighten up a hospital and to give staff, patients and visitors something to look at which would put them at their ease. Water was an obvious choice for the subject since it is always considered to be relaxing, but subject matter alone is not the end of the story. For maximum tranquillity Elaine depicts a wide open space with calming horizontals. The empty sea and sky allow the eye to rest, and the simple description of the buildings is so free and open that it delights the eye without bogging us down in detail. Notice the warm colours here which balance the blue (which can become moody if used in excess) and add a joyous, positive note. The violet in the sea and sky also has a role to play since this is the colour of meditation and helps to ease anguish. Finally, the high viewpoint makes us feel as if we are soaring in the sky, taking our souls up with it.

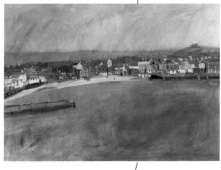

Colour

Like many mixed media artists Elaine is ready to experiment with her colours, just as she is with the media she uses and the way she applies them. She doesn't stick rigidly to a set palette but likes to experiment and has a particular fondness for metallic effects, using interference media plus metallic paints and pencils.

The artist's palette

For 'St Ives, Cornwall' Elaine used a vibrant palette of Liquitex acrylic colours which includes a surprising number of reds. She used light permanent blue, cobalt blue, ultramarine, Prussian blue, Payne's grey, neutral grey, cadmium orange, indo orange red, acra red, napthol red light and medium magenta. If you haven't tried Liquitex paints you may not be familiar with some of these names, but they are based on familiar and reliable pigments. Medium magenta, for example, is based on quinacridone violet, a very strong modern pigment which is an excellent alternative to alizarin crimson.

In her mixed media work Elaine also uses some other exciting paints including Liquitex glitter paints in blue, gold and silver; Liquitex iridescent bright gold and iridescent silver; Finity antique gold paint; Rowney bronze paint and Winsor & Newton Renaissance gold. Over her paints she sometimes applies interference medium (see Pointer) to make it glimmer and shimmer. However, where she wants real impact she applies gold leaf or silver leaf. She also sometimes uses kitchen foil, not necessarily leaving it all on show, but perhaps painting over it so that only a flicker shows through.

Marks on the Sand mixed media on board **91 x 122cm**
The mood of this painting is more upbeat, with more energy than 'St Ives' and this is achieved in part through the more dramatic use of colour. The much stronger blue in the sky carries with it intense power and this is enhanced by the contrast with the large expanse of pale yellow sand – pale colours always make stronger ones look darker and vice versa. This use of light and dark also sets up a great deal of energy, particularly when the two are intermingled, as in the houses, where the lights and darks flicker like lamps switching on and off.

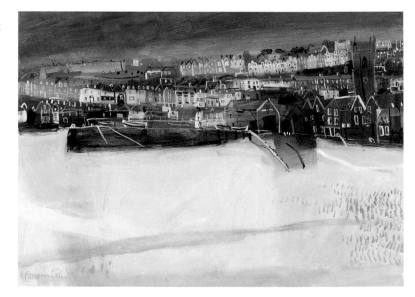

pointer

Interference media

Interference media give you the opportunity to give a metallic finish to any colour on your palette. Cryla interference medium from Daler-Rowney comes in six colours and produces an iridescent, shimmering effect. The medium looks like a clear, slightly tinted gel and is designed to be used over acrylic paint from the same spectrum – use blue interference medium over ultramarine, cerulean blue, cobalt blue and so on. An advantage is that you can decide that an area needs jazzing up at any stage in the painting process and apply it to large or small areas without losing any of the colour patterns already established. Alternatively, try Liquitex iridescent tinting medium which can be mixed with paint of any colour – the more you add the greater the iridescent intensity.

light permanent blue

cobalt blue

ultramarine

Prussian blue

Payne's grey

neutral grey

cadmium orange

indo orange red

acra red

napthol red light

medium magenta

indo orange red napthol red light

acra red cadmium orange

ultramarine medium magenta

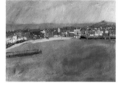

'My keynote is big brushes, bold lines, splodgy areas, paint fast and try not to be tight.'

Technique

Elaine works in a very free way, applying paint, pencil and other materials generously and working quickly, often on huge supports. 'I always use Liquitex acrylic paint and work on boards primed with acrylic gesso – I don't like the feel of painting on canvas and much prefer the firm, robust nature of board. I always use the paint watered down quite thinly and love the quick drying time that allows you to get on two or three layers relatively speedily. I like scoring through the paint to the white board or taking off paint just before it dries to reveal white areas.'

Elaine also likes to use pencil work, not simply as a means of finding the structure of the image but as part of the finished effect, sometimes working over paint – 'a wild scribble can have the effect of loosening up a painting no end'. Karisma pencils are her favourites: 'gorgeous colours and lovely texture; they have gold and silver pencils too which I use a lot. I also love Karisma soluble lead pencils. The very soft ones are wonderful. Try these on slightly wet board for an incredible bold line but be sure of the line because it won't rub out after mixing with paint.'

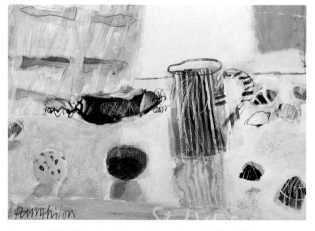

Jug and Shells mixed media on board **43 x 28cm**
This still life picture, also painted in St Ives, is a wonderful exercise in texture making and must have been a great deal of fun to do. The area at the top left has been loosely scrubbed in with a fairly large brush and then drawn and painted over. Beneath it, the sandy area has a much more open texture, created by dabbing with a brush or blotting with paper. On the jug and foremost shells Elaine has scratched back into the nearly dry paint, taking it right back to the white of the board.

shortcuts

Gesso ground
True gesso is a traditional surface which has been favoured by artists for centuries and was commonly used for egg-tempera work. It is made from equal parts of whiting (chalk) and glue size. The glue size is made by mixing shavings of rabbit-skin glue in hot water, a process so smelly as to put off all but the most hardened traditionalist. It may still have its benefits if you are working mainly in oils, but for acrylics ready-made acrylic gesso offers a much more pleasant alternative, although you can work on traditional gesso if you prefer (use it only on board or wood because it will crack on canvas). Modern acrylic gesso can be used as a primer on most porous surfaces in conjunction with all types of paint. It is white and runny and can be mixed with about ten per cent paint to create a coloured ground. Lightly sand it for a smooth finish or leave your brushmarks showing for a bit of texture.

Elaine worked the pier over the blue of the water, applying the browns of the structure quite lightly and thinly for a broken-colour effect. As well as enlivening the surface texture this has a harmonising effect, helping to link pier and water more completely.

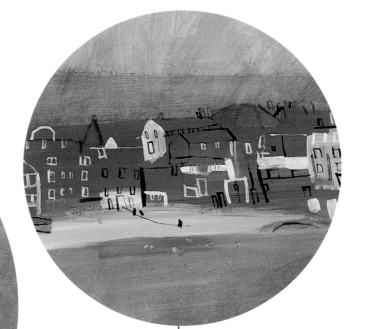

Here you can see how Elaine has roughly blocked in the grey of the buildings as a single entity, then worked on top with a small brush using her lights, darks and a few colours to plot the outlines and basic details of the houses. This simplicity of approach creates a very fresh look which is easy on the eye.

Big, bold, active and spontaneous are key to Elaine's way of painting. Here you can see her bold brushwork, which is loose and deliberately uneven to create a textured effect that captures some of the activity of water.

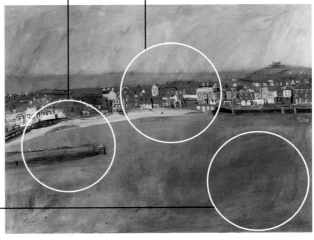

Acrylic 119

Nick Andrew doesn't need to travel to seek out subjects to paint – he finds beauty close to hand, so why go further? 'I have spent a large part of the past six years getting to know a two-mile stretch of the River Wylye, close to where I live in South Wiltshire. I walk here often, observing, painting, drawing, taking photographs and making notes. Sometimes I work from the riverbank or from the surrounding watermeadows, but I also work from shaky plank bridges, clinging to overhanging tree branches or I wade in the river itself. I find it constantly fascinating and compelling and am drawn in particular by the abstract qualities of the river: patterns in the flow, the multi-layering and reflective quality of the water.

'I'm very interested in the concept of painting and drawing as inquiry and also of working from my immediate surroundings. By limiting the field of interest to a small stretch of the river I now know it very well but I am finding out more all the time about how the river and the life that it supports functions and changes over hours, days, seasons and years.'

Verticilla by Nick Andrew acrylic on board **72 x 72cm**

'I am finding out more all the time about how the river and the life that it supports functions and changes over hours, days, seasons and years.'

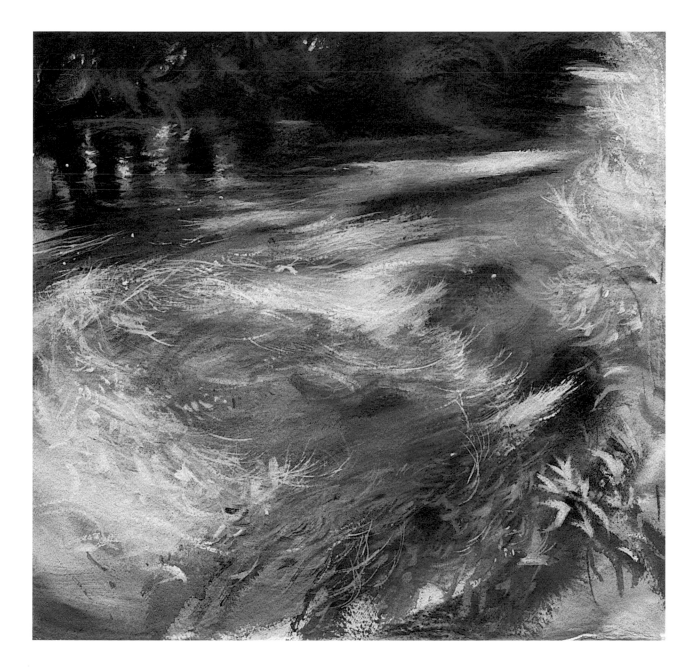

Composition

Sometimes Nick works out the placing of a painting's motif in his sketchbook, but more often he works directly onto the painting surface itself, basing the composition on a set of gathered references. 'I find the direct approach more exciting as it is also less predictable.' This excitement empowers his paintings and thereby the subject matter, so that in 'Entagliare', for example, we can really feel the rush of the river as it hurtles over the riverbed and rebounds off rocks in its path.

Nick tends to focus on small snatches of the river, often centring on the water itself – its shapes, its colours and its moods. This gives his work an abstract quality because much of the support is given over to the pattern of reflected light, shade and colour in the water. The narrow field of view also intensifies the emotional values – it is as if we have just glanced down at this scene and it has filled our whole being.

Highly attuned to the abstract qualities of a scene, Nick knows the importance of the balance of forms in creating a good composition. 'I feel that the initial impact of every painting is as an arrangement of abstract shapes. So I try to interpret the subject, make the design, and begin the painting following that principle.'

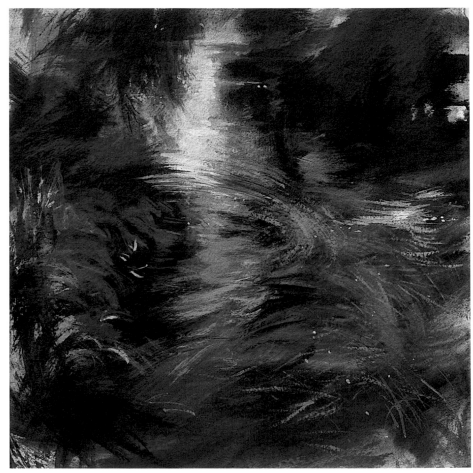

Entagliare acrylic on board **58 x 58cm**
'My aim is for each painting to revolve around a particular motif or aspect of the river. This could be anything from a pattern of ripples to the reflection of a cloud dissolving into a clump of water-crowsfoot. It is generally these motifs which inspire the titles. "Entagliare" is from tagliare which means cut – the repeated ripple pattern looked as if it had been incised into the water.'

The main motif in 'Verticilla' is the swirl of watercress in the foreground – the title comes from verticillus, meaning whorl – and Nick uses several compositional devices to ensure that we look here and keep looking here. For example, the patches of bright orange leap out to catch our eye while the line of pale colour in the water leads us directly back here if our attention has wandered upstream.

Once he has us looking at the whorl, Nick ensures we stay here. The wall of foliage on the right acts like a barrier to hem us in, and the dark line of trees along the top does the same. The large swirl itself brings us round and in if we try to 'escape' out of the left or bottom of the painting.

Most of the energy in the image is concentrated on the swirl which is busy, even frenetic. This area contrasts pleasingly with the stiller waters in the top left and top right which enhance the power of the watercress through contrast.

golden rule

Cooking up the right balance

The process of balancing forms, colours and emotions in a painting can be compared to the process of cooking. A good painting, like a good dish, should be distinctive and this demands the emphasis of one or two ingredients. However, if you overdo it the result can be overpowering or unrefined. So just as if you are cooking, think all the time of how the elements work together and how the balance of 'flavours' is coming along. Start with the abstract shapes which are the basic building blocks or raw ingredients, and make sure that they balance well. If the fundamentals are right the picture should develop smoothly. Then slowly add more touches, always balancing one with another. You'll find everything runs like clockwork this way.

Colour

Nick mostly uses Finity acrylics from Winsor & Newton. 'They flow and diffuse well when diluted but also have good body and hold a brushmark when used from the tube.' His palette of ten colours (including white) is capable of producing everything he needs. The pure colours of his palette provide him with a good, basic and versatile vocabulary for describing and interpreting the colours in Nature. The intensity of colour in Nick's paintings is partly achieved through the selection of bright colours in his palette but he gives the painting a boost by starting with heightened colours. For example he might use crimson mixed with cadmium yellow as a base colour – 'often the riverbed has a warmth which is intensified by direct sunshine'.

The artist's palette

Nick's palette comprises: alizarin crimson, cadmium red medium, cadmium yellow deep, lemon yellow, phthalo green (blue shade), cerulean blue, phthalo blue (green shade), ultramarine, dioxazine purple and titanium white.

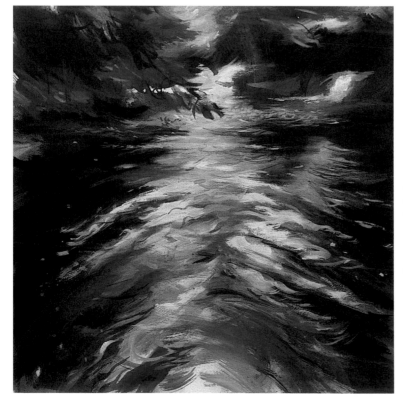

alizarin crimson cadmium yellow

Ampulla acrylic on paper **46 x 46cm**
A forceful use of intense colour energises and empowers Nick's work and helps to bring out its abstract qualities. Here the strong yellow, inky blacks and flashes of red would strike a note of anger if used on their own, but together serve to balance and control each other. Nevertheless, we are left with an impression of the deep forces that lay beneath the surface.

Notice the way the colours combine to emphasise the forward push of the water. This is the subject of the painting – ampulla is a term for the dilated end of a vessel, just like the shape of the water.

alizarin crimson cadmium red medium cadmium yellow deep lemon yellow

phthalo green (blue shade) cerulean blue phthalo blue (green shade) ultramarine dioxazine purple

lemon yellow cerulean blue lemon yellow phthalo green (blue shade)

pointer

Minimise mixing

To retain the brilliance of your paints and to avoid muting them too much, limit your mixes to just two colours (plus white if necessary) and use colours unmixed if you can. The more colours you add to a mix, the more you will muddy them. This is fine if you want a soft look, but for high key pictures mixing should be kept to a minimum.

Technique

'The pictures shown here were painted in my studio. The main element takes place with them flat on the floor. I use a heavy watercolour paper which will take a real soaking and flood on transparent colour rapidly to establish the principle "blocks" of the image. The paint flows, runs and diffuses and is allowed to dry. I re-wet the paper and lay down more fluid paint, encouraging some areas to flow more by spraying them with water. This process of wetting, working and drying continues until the darks begin to have a sense of depth. Then I put the painting on the easel and start working with colour with more body to establish definition, lights and textures. At this stage I use many techniques, dragging the paint with the brush, splattering some on and using whatever tools seem necessary or appropriate including brushes, sticks and fingers.'

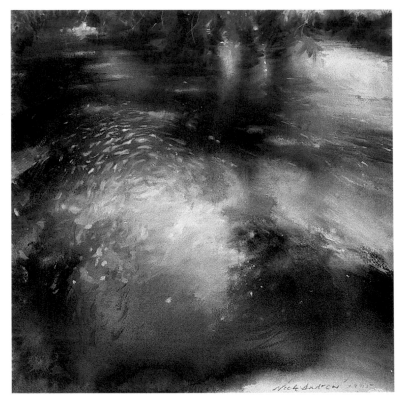

shortcuts

Multi-faceted acrylic

Acrylic is a wonderfully versatile medium. You can dilute it, as Nick does, to create varied washes in the same way as with watercolour, or you can use it much thicker, straight from the tube or mixed with mediums to create fascinating textures as Nick does towards the end of the painting process. You can apply it thick with a knife, brush, piece of card or finger and then use any of those tools to give it further texture. You can scratch back into it, glaze over it and even scrape bits off and start again – every one of these creates surface interest. Try spattering, too, being sure to mask the surrounding areas first to prevent colour going in the wrong place. The only thing you need to watch for is the fast drying time of acrylic. Once it is dry it can't be washed off so be careful not to create too lively a texture if that's not what you want.

Broddr acrylic on paper **38 x 38cm**
Here you can see clearly how Nick starts with diluted washes, built up layer upon layer until the tones are strong and then works on top with thicker paint. Here it is used quite sparingly for the dappled pattern of light on the water and for the foliage of the trees.

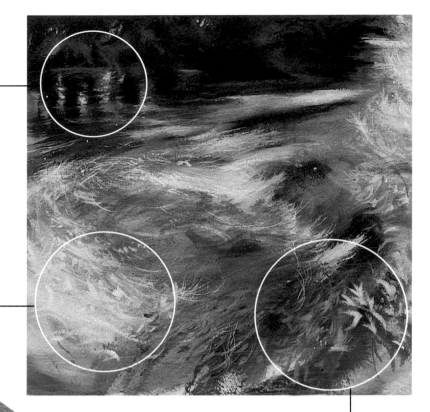

Diluted acrylic is perfect for capturing the translucency of water. Here it contrasts with the paler opaque layers of colour which are used to describe reflected light and form.

Where the paint is less dense, as here, you can see how the paint is built up. The yellow-green which is a surface colour in the water also shows up as a base colour here, as does some of the mid green. Repeating colours at different stages of the painting process in this way helps to create a harmonising effect.

Nick uses a fine brush to define the thin stems of the watercress but he keeps the effect impressionistic. Too much detail would upset the balance of the image.

Acrylic 127

SEASCAPES ACRYLIC

Terry McKivragan is a relatively recent convert to acrylics, having spent many years as a watercolour artist and before that as a designer and illustrator. He was drawn to acrylic because he wanted to put more texture into his paintings and work in a more physical way. Acrylic was the obvious choice, being closer to watercolour than oils and being quicker to dry. Nevertheless, he works like an oil painter, starting with thin, watery layers of paint and working up to thicker and thicker consistencies.

Terry uses a camera to provide his references, keeping it with him at all times on the basis that 'potential subjects often present themselves when you are not looking for them'. This was the case with 'View of Rye' because he spotted this likely scene on a casual ramble around the harbour area.

View of Rye by Terry McKivragan acrylic on board **74 x 74cm**

'Painting must do for the eyes what poetry does for the ears.'
(Antoine Coypel 1661–1722)

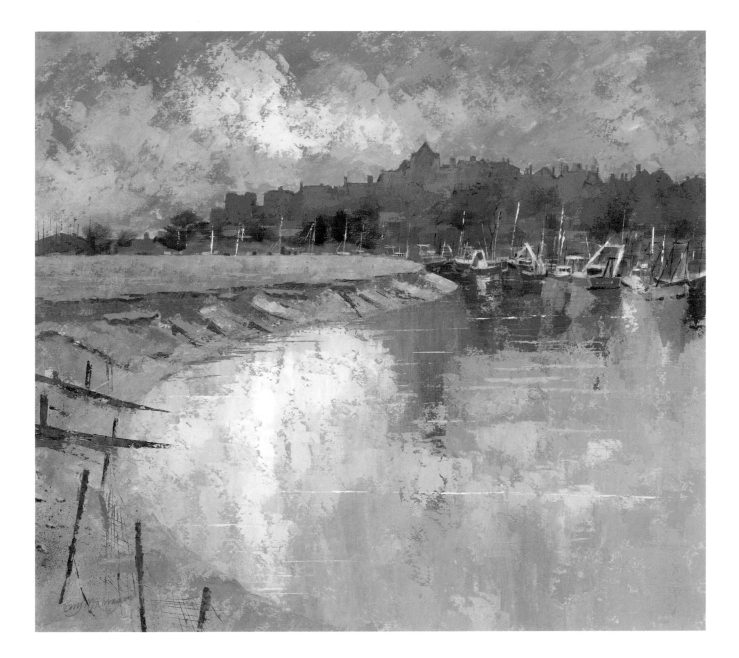

Composition

Terry has a strong eye for composition. Indeed this is what he concentrates on when looking around for suitable scenes to paint – the colours he can add later, embellishing them or even inventing his own to give the painting impact. He was exploring Rye harbour one day when he 'discovered that by looking back from the river mouth I would have a view taking in the river with its curving bank leading up to a strong horizontal line. The solid area of the hill above continued on up to the natural focal point of the church tower.'

 Back in his studio Terry chose a square format for his painting of the harbour 'because I like the proportions of the areas created by the horizontal line that I am so fond of, whether it be high or low in the picture but never halfway. In this case I chose to place the horizontal line high in the picture as I could see there was great potential for reflections on the water and textures on the muddy banks and also for providing the space to show off the inverted "S" of the shoreline.'

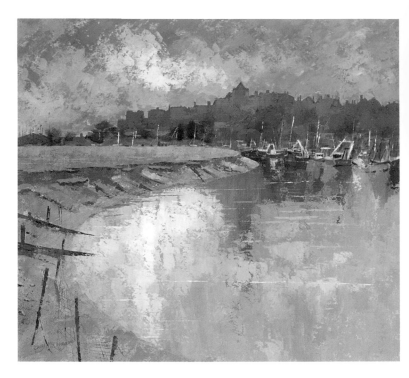

golden rule

Drawing the eye with colour

Terry thinks of colour in terms of its compositional role as well as in terms of its impact and harmony. In both pictures shown here he uses it to draw the eye to focal points. In 'Istanbul from East to West', for example, he brightens the colours of both mosques and does not repeat these colours again except for their reflections, even though in reality the colours of their stones are echoed on nearby buildings. By making them the most colourful objects in the image Terry ensures that the mosques stand out and draw the eye. He uses the bright colours of the boats in 'View of Rye' to similar effect.

The inverted 'S' shape of the muddy riverbank was what first attracted Terry's attention and he gives it plenty of space in the finished painting, bringing it in more than halfway across the picture area before sweeping it back in a lavish curve.

Terry has picked out and heightened the bright colours of the boats to form a focus which drives our eyes up and round the curve of the river bank towards them. Notice how he has given the boats large reflections in the water, enabling him to allow them greater space on the support and thereby increasing their impact.

By putting the houses and trees into silhouette Terry was able to devise an area of relative quiet behind the boats and to create a deep backdrop for them which brings out their colours. The reflections of these dark forms also help to bring out the brilliance of the boat reflections by comparison.

Istanbul from East to West acrylic on board **59.5 x 68cm**

Terry's original reference photo (not shown) presents a mass of pale buildings and boats, but Terry sees its potential. He knocks out unnecessary detail such as windows and balconies and even suppresses some of the buildings by putting them into shadow. The addition of the two boats gives interest to an otherwise blank area and balances the weighty forms of the mosques. The ferry boat was photographed travelling in another direction, so to check that he could combine the boat with the landscape, Terry made a small sketch.

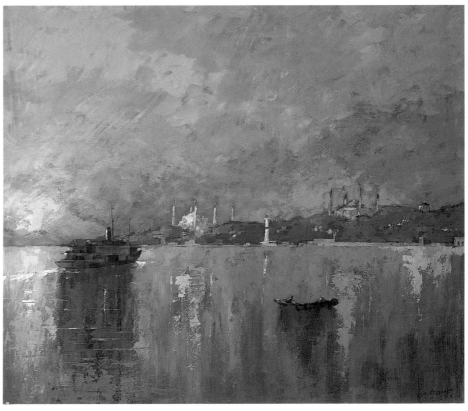

Colour

Terry works in his studio so he can have plenty of space – both mental and physical – to experiment with colour. 'I am well aware of how an ordinary view with no distinguishing landmarks can be transformed by imaginative colour into a really exciting painting.' In 'View of Rye' the distinguishing landmarks were there, but the natural colour was still lacking, 'giving me the opportunity to create a more colourful and dramatic painting'.

In 'Istanbul from East to West' the colour theme was influenced by the lighting in the photographs, 'the combination of dark blues, greens and purples setting off the dramatic effect of the light shining on the mosques'.

The artist's palette

'I keep to a limited palette, but not rigidly so, favouring yellow ochre, cadmium yellow, cadmium red, French ultramarine, Hooker's green, burnt umber and white plus colours like magenta and turquoise which, with some added white, inject sparkle.' This is a good basic palette, enabling the artist to mix most colours. The addition of one or two bold ready-made paints adds a bit of fizz and prevents Terry from becoming complacent with his colour mixing.

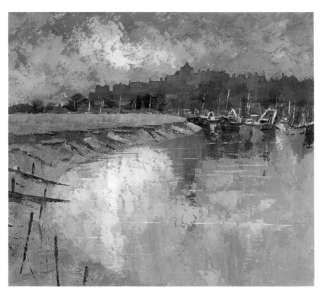

Terry puts colour everywhere here, transforming a drab day into a spectacular sunset. As well as the obvious metamorphosis of the sky, notice the purple, blue and pink that replaces the greenish brown mud of the riverbank and the wonderful dark turquoise of the buildings and their reflections. What is really clever is how Terry manages to maintain a colour balance. Simply changing the sky would have looked ridiculous – all the other elements had to follow suit, and this process is what requires the artist's eye.

phthalo turquoise French ultramarine

cadmium yellow cadmium red

yellow ochre

cadmium yellow

cadmium red

French ultramarine

burnt umber

magenta

phthalo turquoise

Hooker's green

magenta French ultramarine

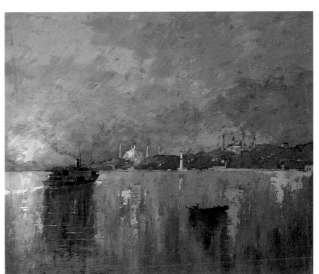

As if they are the stars and moon, the mosques reflect light from some hidden source. Their bright colours illuminate the whole picture, warming it and enlivening it like welcome lights in a window.

pointer

Analogous harmonies

Terry has based both the paintings shown on these pages around a group of colours which appear next to each other on the colour wheel – red through to yellow for 'View of Rye' and violet through blue to green in 'Istanbul from East to West'. If these colours can be mixed from two primaries such as red and yellow or a primary and adjacent secondary such as red and violet then they are known as analogous colours. However you choose to work it the effect is always harmonious and the heavy colour bias can be powerful.

Technique

'I am particularly interested in exploring the intrinsic qualities of paint and like to see a painting where the texture of the paint forms an integral part of that painting. With acrylics the opportunities are good for achieving these aims. I start with a selected pencil sketch, working in some detail, especially if it involves, say, buildings or as in the Istanbul painting, the boat. I work initially using the paint as watercolour, loosely applying washes with a large soft brush – an all-over wash to begin with, creating marks which may still be visible at the final stage. Then I add washes to pick out particular areas which I have already drawn in with pencil.

'Once the basics are in I move on to thicker paint, putting in the smaller areas of detail with a small flat brush and finally using a knife to lay thickly mixed paint over the washes. This gives the contrasting effects and textures where the thick overpainting allows the washes below to show through. Sometimes at this stage I will then add a wash as a glaze, laying it over with a soft brush to modify a colour or generally warm up a painting.'

shortcuts

Using a painting knife

We all learn to paint with a brush and for many the transition to a knife can be frightening. It helps if you remember that not being a brush you shouldn't expect it to do the same things or handle in the same way. Instead, use it to do what it is good at – to introduce a range of exciting new textures and marks. Terry takes much enjoyment in its use. 'Used flat it creates thick textures but using the edge it is also effective for such details as the masts on the boats and the posts in the foreground.'

Terry finds his painting knife invaluable for adding linear details such as the masts and rigging of the boats, the posts in the foreground and the lines in the water. These are added at the final stages.

By slowly building up the texture of the paint Terry starts to develop the picture surface. Once the initial washes are in he adds thicker paint with a brush, plotting areas like the trees and building up the dark shadows on the hill which will later be partially covered by thicker scumbles of paint.

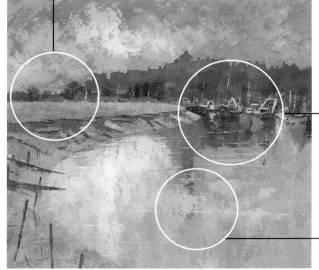

By scumbling on paint with the flat of his knife Terry creates ragged-edged areas of smooth colour, leaving areas of the underpainting and coloured ground to show through for contrast.

Portfolio

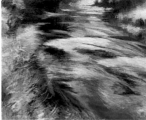

NICK ANDREW studied Art and Graphic Design in Oxford, London and Cheltenham. He has exhibited his work widely in the UK, mainland Europe and the USA and has had regular solo shows at the Beatrice Royal Gallery, Eastleigh; Black Swan Gallery, Frome; Courcoux & Courcoux Art, Stockbridge; Original Arts, Harrogate; and Blue Rider Gallery, Mere. Nick was a finalist for the Laing Open in 1994 and won first prize in 'Dorset Rivers' at Poole Art Centre in 1994. He won first prize in the Spink-Ledger Prize in 1998 and was a finalist in 1999. To see more of his work, contact any one of the galleries above or at:
Bull Mill
Crockerton
Warminster BA12 8A
UK

(pictures)
Oppilara
Yeat 1
Espa

RAY BALKWILL is a professional artist who studied at Exeter College of Art. He worked in advertising as an art director but increasing demand for his paintings led him to give up his job to become a full-time artist. He has shown in numerous exhibitions, including those of the Royal Institute of Painters in Watercolour, the Royal West of England Academy and the South West Academy of Fine and Applied Arts. He runs painting courses and writes for numerous art magazines including 'The Artist'. His paintings can be found in private collections and galleries in the UK and abroad. To see more of his work contact him at:
Thistledown
Marley Road
Exmouth
Devon EX8 4PP
UK
Tel: +44 (0)1395 270 278

(pictures)
Pounding Surf
Talland Bay

MIKE BERNARD trained at the West Surrey College of Art & Design, Farnham, followed by postgraduate studies at the Royal Academy Schools. Since then he has exhibited at the Royal Academy Summer Exhibition, Mall Galleries, Royal Festival Hall and many other galleries in London and England. He has won awards including the Stowells Trophy, the Elizabeth Greenshield Fellowship, Silver Longboat Award and Laing Award. Mike was elected a member of the Royal Institute of Painters in Watercolour in 1997 and was awarded its Kingsmead Gallery Award at the Mall Galleries in 1999. He teaches in Chichester, Farnham and Petersfield and will be holding summer landscape painting courses both locally and abroad. Contact him at:
Old House Farm
Nursted, Petersfield
Hampshire GU31 5RD
UK

(pictures)
Polperro, Winter
Porlock Weir
Portsmouth Harbour

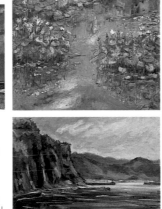
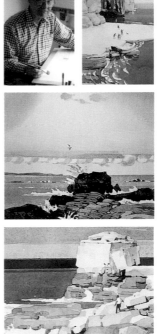

ANDREW BRESLIN studied at the Jacob Kramer College of Art in Leeds and the Falmouth School of Art in Cornwall. He did postgraduate research in Art, Myth and Communication before becoming a designer. He is now senior partner in a visual communication practice and works as an artist.

ROBIN STANDEVEN studied at Bretton Hall College, Leeds and became an art teacher in Leeds and then Stage Manager for the BBC. He now works as a freelance events manager coordinating large-scale events as well as working as an artist.

Andrew Breslin and Robin Standeven have held a number of exhibitions of their work together, including at the Kranister Gallery, Vienna; the A3 Gallery, Eferding; The Design Innovation Centre, Leeds; and at the Harvey Nichols store in London. Contact Robin at:
1 Monk Bridge Street
Meanwood
Leeds LS6 4HL
UK
or visit their web site:
www.lmu.ac.uk/ces/axis

(pictures)
Blue Danube
Land/Sky Rhythm
So Below, the Mountain

MARGARET GLASS has had her work accepted for prestigious shows around the world, including the Royal Academy and Paris Salon (Société des Artists Français). She is a member of the Pastel Society, London, the Royal Society of Arts, London and Société des Pastellistes de France, and in 1986 was awarded the Diplôme Prix d'Honneur and later the Maître Pastellist by the Société des Pastellistes. In 1991 the society also invited her to teach in Paris for them. Her work has been exhibited in many venues including in Buffalo, New York and at the Galerie d'Art in Paris. To see more of her work, contact her at:
Stowlangtoft Hall
Stowlangtoft
near Bury St Edmunds
Suffolk IP31 3LY
UK

(pictures)
Blue and White Spinnaker
The Water Gate, Venice
East Runton Beach

JIRO HYODA was born in Osaka, Japan and graduated from the Wakayam University. He entered his family's shipping business after graduating and is now Senior Managing Director. Since 1983 he has been studying under the abstract artist Kazuo Siraga. He has held many one-man exhibitions of his own work, notably at the Gallery Haku-un and the Taisho Bank, Osaka. To see more of his work, visit his website:
www.bekkoame.ne.jp/i/hyoda

(pictures)
Banpak Park
Imakoura

RON JESTY was formerly a graphic designer and has painted all his life. His subjects are largely derived from still life and the land and seascapes of West England. Ron is the author of 'Learn to Paint Seascapes', Harper-Collins, and contributes to 'The Leisure Painter' and 'International Artist'. His work has also been included in several books on drawing and painting. He has held one-man shows including at the Brewhouse, Taunton; Art Centre, Yeovil; and The Gallery, Dorchester. He has exhibited at the RWS annual and Royal Academy Summer exhibitions. Contact him at:
24b Brunswick Street
Yeovil
Somerset BA20 1QY
UK
Tel: +44 (0)1935 426 718

(pictures)
Dancing Ledge 3
The Lonely Sea and the Sky
Pulpit Rock 3

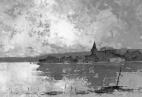

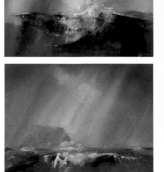

MICHAEL MAJOR has an MA from the Royal College of Art and a Diploma in Painting from Birmingham College of Art & Design. His work has been seen in numerous group shows including 'Thirty London Painters' at the Royal Academy and several group shows at Waterman Fine Art, London. His one-man exhibitions have all been in London, most recently at E1 Gallery, Bird & Davis Gallery and Letherby Gallery, Central St Martins. Contact him at:
171 Norwood High Street
London SE27 9TB
UK

(pictures)
Seas Eye View
Brilliant Edge
Violet Gaze

TERRY MCKIVRAGAN has a Diploma in Design from Wimbledon Art School and worked for many years in commercial art, finally running his own graphic design studio but meanwhile making watercolour landscapes for his own pleasure. In 1986 he became a freelance artist, first concentrating on watercolours and more recently moving over to acrylics. He is a member of the Royal Institute of Painters in Watercolour and exhibits with the Royal Society of Marine Artists and Royal Society of British Artists. Additionally his work has been shown in numerous exhibitions and galleries. His work has also been published as limited edition prints, greetings cards and calendars. Contact him at:
The Old Pottery Building
Down Lane
Compton
Guildford GU3 1DQ
UK

(pictures)
The Beach at Worthing
Fishing Boat on the Beach
Across to Bosham

PETER MISSON is a self-taught artist. Despite the considerable promise he showed as an artist in his youth he turned his mind towards the sea and it was only in the early 1980s that he started to take art more seriously again. He studied the work of the Masters, often copying their drawings in the art school tradition and has spent the last 20 years developing his style and finding his own voice through paint. Contact him at:
223 Farm Hill
Exeter
Devon EX4 2ND
UK
or view more of his work at:
Mid Cornwall Galleries
St Blazey Gate
Par
Cornwall PL24 2EG
UK

(pictures)
Sunrise
Grand Anquette Beacon, Jersey
Rounding Berry Head

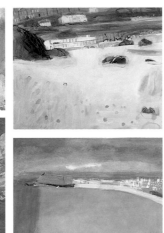
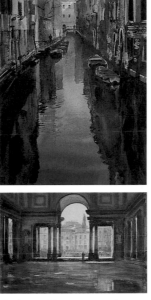
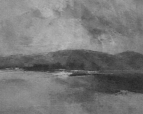

LINDA NORRIS has a BA Honours degree in Fine Art from University College of Wales. She has held several solo exhibitions including shows at The New Academy Gallery, London; Aberystwyth Arts Centre, Gwent; and Wexford Arts Centre, Ireland. Group exhibitions include 'Welsh Landscapes', New Academy Gallery London, 2001; Contemporary Art Fair 2000, London; 'New Faces', Kingfisher Gallery, Edinburgh; and Wales Drawing Biennale 1999. Both 'Foxglove Seas' and 'Winter Shore' are available as limited edition fine art prints. To view more of her work, contact her at:
The Manse
Trefgarn Owen
Haverfordwest
Pembrokeshire SA62 6NE
UK
Tel: +44 (0)1348 831 108
or email her at:
linda@linda-norris.com
or visit her web site:
www.linda-norris.com

(pictures)
Golden Seas
Gusting Cloud

ELAINE PAMPHILON is an artist and concert harpist. Combining a growing interest in art with her musical background she went to Homerton College, Cambridge and studied art under Kay Meizi. After leaving college Elaine worked as a professional harpist but continued her art, holding her first exhibition in 1986 at Newham College, Cambridge. Since then her work has been shown in numerous galleries throughout the UK including the Yew Tree Gallery, Stroud, Gloucestershire; the Thompson Gallery, London; and the Juliet Gould Gallery, Mevagissey, Cornwall. To view more of her work, contact her at:
The Old Rising Sun
Apthorpe Street
Fulbourn
Cambridge CB1 5EY
UK

(pictures)
Yellow Houses on the Cliff, Porthmeor
The Island from Man's Head, St Ives

CECIL RICE graduated from Brighton Art College. He has a passion for Italy, especially Venice, which he visits regularly on painting trips. His meticulous attention to drawing is evident in many of his paintings and it is this, combined with a fluidity and breadth in handling light and colour, that gives his work its strength. His work has been exhibited widely in England. View more of his work at:
Red Dot Gallery
22b Bellevue Road
London SW17
UK
Tel: +44 (0)20 8672 6086
or visit their web site:
www.reddotgallery.com

(pictures)
Gondolas, Venice
Morning, the Uffizi

KEITH ROPER studied Painting and Graphic Design at Lincolnshire College of Art & Design. A member of the Pastel Society and Lincolnshire Artists Society, he exhibits his work at the Pastel Society show at the Mall Gallery, London and at the Lincolnshire Artists Society exhibition at the Usher Gallery, Lincoln. He has won a number of awards including the Judith Oyler Painting Award, Christopher Asherton Stones Progressive Picture Award and Daler-Rowney Best Picture for a Non-Member at the Pastel Society in 1995. His work is featured at the Linda Blackstone Gallery, Pinner, Middlesex; the Thompson Galleries, Church Street, Stow-on-the-Wold; and Kentmere House Gallery, York. Contact him at;
10 Heath Close
Welton
Lincoln LN2 3JY
UK

(pictures)
Beach near Lepe
Solent Shoreline, Keyhaven

Colour Characteristics

Here is a rough guide to the different qualities of paint colours used by the artists in this book. Note that paints vary from brand to brand and from medium to medium so always check with the manufacturer's descriptions of the paints. For best results use a good brand of artists' quality paints such as those by Winsor & Newton. Manufacturers are constantly improving and updating their ranges, and although it is satisfying to use the same colours as the Great Masters of old, many of the modern colours are far superior in terms of handling and lightfastness, so don't get stuck in a rut – try something new.

ACRA RED – a dark, cold red based on the highly reliable quinacridone red pigment; strong; transparent; totally lightfast.

ALIZARIN CRIMSON – popular violet-red; transparent; oil colour can crack if it is applied thickly; watercolour is prone to fading when applied thinly; not totally lightfast; consider quinacridone red or violet as an alternative.

ANTIQUE GOLD – Finity acrylic colour with a more ochre-like tinge than their standard gold colour; opaque; permanent.

BRIGHT AQUA GREEN – mid blue-green based on phthalo blue, phthalo green and white pigments (see light permanent blue); opaque; totally lightfast.

BURNT SIENNA – clear earth colour made by heating raw sienna; similar to Indian red; transparent when very diluted, opaque with less dilution; absolutely lightfast.

BURNT UMBER – made by roasting raw umber; transparent when very diluted, opaque with less dilution; absolutely lightfast; fairly powerful tinting strength.

CADMIUM LEMON – the lightest, coldest yellow; greenish; very lightfast; quite strong tinting power.

CADMIUM ORANGE – intense bright orange; opaque; lightfast; fairly powerful tinting strength.

CADMIUM RED DEEP – similar to cadmium red in quality but a deeper colour.

CADMIUM RED – bright, warm red; opaque; totally lightfast; good tinting strength.

CADMIUM YELLOW – clean and bright mid-yellow; opaque; lightfast; reliable. The deep and light versions have the same basic qualities but vary only in tone.

CERULEAN BLUE – bright greenish blue; opaque; tends to granulate in watercolour; lightfast; quite low tinting strength.

COBALT BLUE – originally derived from crystals; transparent; lightfast; weak tinting strength.

COBALT TURQUOISE – blue-green; fairly opaque; lightfast; useful for painting water.

COBALT VIOLET – available in light or dark version; violet colour which leans towards red or blue depending on the manufacturer; transparent; excellent lightfastness; weak tinting strength.

DEEP MAGENTA – see magenta.

DIOXAZINE PURPLE – deep mauve based on carbazole dioxazine; not reliable as a watercolour or gouache; low chroma; transparent; not totally lightfast.

EMERALD GREEN – mid green originally made with lots of arsenic so it was highly toxic, not just to artists and their assistants but even to those living with it; now made from varying pigments of mixed reliability but usually lightfast.

FLAKE WHITE – derived from lead and therefore highly toxic if taken internally, even in small doses; wonderfully bright white used by the Ancient Egyptians and Chinese; only suitable as an oil or alkyd; extremely durable.

FRENCH ULTRAMARINE – see ultramarine.

GAMBOGE – warm yellow watercolour; the genuine version comes from tree resin and is highly fugitive although Winsor & Newton's version is permanent; transparent; staining colour.

HOOKER'S GREEN – a mid green which varies in colour and quality from brand to brand.

INDIAN RED – brownish red; originally derived from red earth; absolutely lightfast; covers well; economical.

INDIAN YELLOW – originally derived from the urine of cows fed on mango leaves; varies in quality from brand to brand from lightfast to a paint which fades rapidly; fairly transparent.

INDIGO – deep inky blue; originally derived from plant leaves; transparent; may be fugitive.

INDO ORANGE RED – hot, almost luminous orange; transparent; totally lightfast.

INTERFERENCE MEDIUM – acrylic medium

which looks semi transparent; available in a few basic colours such as blue, green, red, violet and gold; apply over colours of the same spectrum (i.e. blue interference medium over blue paint) to make it shimmer like metal.

IRIDESCENT BRIGHT COPPER – shimmering red-brown acrylic colour from Liquitex; based on yellow iron oxide pigment; translucent; excellent lightfastness.

IRIDESCENT BRIGHT GOLD – pale, shimmering yellow-gold made with coated mica flakes and yellow iron oxide pigment; translucent; totally lightfast.

IRIDESCENT SILVER – pale, shimmering silver-grey; translucent; totally lightfast.

IVORY BLACK – originally derived from charred ivory but now made from charred animal bones; warm to neutral black; opaque with good covering power; absolutely lightfast.

LAKE – a bright pigment generally used in inks or for dyeing textiles produced by combining an organic colouring matter with an inorganic compound such as metallic salt.

LAMP BLACK – slightly bluish black; basically made from soot which has been heated to remove any oil; opaque; extremely strong tinting strength; totally lightfast.

LEMON YELLOW – see cadmium lemon.

LIGHT PERMANENT BLUE – pale, cool green based on phthalo blue, phthalo green and white pigments (see also bright aqua green); opaque; totally lightfast.

LIGHT RED – earth colour; generally opaque; absolutely lightfast.

MAGENTA (QUINACRIDONE) – very strong pink; opaque; excellent lightfastness in most media but may not be so good in watercolour.

MARS BLACK – deep, dense black; opaque; lightfast; very strong tinting colour.

NAPLES YELLOW – usually a delicious blend of cadmium yellow and white; opaque; lightfast.

NAPTHOL RED – hot orange-red; transparent; totally lightfast.

NEUTRAL GREY – also called neutral tint; basically a mix of black and white; exact colours and qualities vary according to the manufacturer.

NEW GAMBOGE – see gamboge.

PAYNE'S GREY – soft blue-black; lightfastness depends on the brand; covers well.

PERMANENT ROSE – lighter, fresher pink than permanent magenta; transparent; lightfast; staining colour.

PHTHALO BLUE (GREEN SHADE) – acrylic colour; strong mid-blue; transparent; lightfast.

PHTHALO GREEN (BLUE SHADE) – acrylic colour; strong mid-green, similar to viridian; transparent; lightfast.

PHTHALO TURQUOISE – strong cool green; transparent; totally lightfast.

PRUSSIAN BLUE – deep greenish blue; transparent; very powerful tinting strength; lightfast, though some brands bronze with age; similar in colour to the reliable phthalo blue.

RAW SIENNA – soft yellow earth colour, similar to yellow ochre; good opacity; absolutely lightfast.

RAW UMBER – warm brown earth colour; cool, greenish brown; can darken over time; lightfast.

ROSE DORÉ – lake version of rose madder; pale pink, creamier than rose madder; transparent; lightfastness may vary.

ROSE MADDER – originally derived from the madder plant; wonderful soft rose colour; transparent; some brands are extremely fugitive so check with the manufacturer's details before you buy.

SAP GREEN – originally produced from buckthorn berries; soft, earthy green; lightfastness varies according to brand but may only be moderate.

SCARLET LAKE – usually a hot red although colours and qualities vary considerably depending on the manufacturer so check for characteristics before you buy.

TERRE VERTE – green earth pigment used since early times; fairly opaque; lightfastness depends on the brand; low tinting strength.

TITANIUM WHITE – inexpensive bright white; not as toxic as flake white; very opaque; absolutely lightfast.

TURQUOISE – see phthalo turquoise or cobalt turquoise.

ULTRAMARINE – originally derived from lapis lazuli and therefore highly prized; wonderful bright violet-blue; transparent; absolutely lightfast; good tinting strength.

VANDYKE BROWN – the true pigment comes from decomposed vegetable matter and isn't lightfast, but modern paints sold under this name are usually made from modern materials and vary from totally lightfast to moderately so; a cold, earthy brown; generally transparent.

VENETIAN RED – earth colour now often made from a synthetic iron oxide; hot red-brown; opaque; absolutely lightfast.

VIRIDIAN – excellent, strong, clear bluish green; lightfast; transparent; stains overlaid colours readily.

WINSOR BLUE – Winsor & Newton colour which is basically phthalo blue; strong; transparent; permanent.

YELLOW OCHRE – muted yellow earth colour; generally strong; similar to raw sienna but more transparent; absolutely lightfast.

Glossary of Terms

ACRYLIC – a fast-drying, modern painting medium made by combining pigment with acrylate resin. It handles like oil paint or alkyd when thick and like watercolour when thinned, and it dries quickly to a water-resistant finish which does not yellow. Acrylics are water-soluble when wet so they are often adopted by painters who work in mixed media. Liquid acrylics have the quality, feel and colour depth of ink.

ALKYD – a modern type of oil paint that dries much quicker than oil. It may be used on its own or combined with oil paint to speed the drying time.

BINDER – the substance that binds the pigment together to make paint such as gum Arabic or linseed oil.

BLENDING – the method of combining two colours where they meet so that it is impossible to tell where one colour ends and the next one begins. Blending is usually done with a brush, rag or finger.

BROKEN COLOUR – where colours are applied next to each other in small amounts so that from a distance they appear to mix. The result is a shimmering effect which captures the qualities of light very well.

COMPLEMENTARY COLOURS – opposites on the colour wheel. Examples are red and green; yellow and violet; blue and orange. When placed together complementary colours seem to make each other look more vibrant, but when mixed they create soft neutrals. Compare with split complementaries.

CONTRE-JOUR – a term which literally translates as 'against the day'. It refers to the practice of painting with the light coming towards you instead of working in the usual way with it behind you or to one side and it tends to give objects an aura, imbuing the painting with a magical feel. It is difficult to see with the sun in your face but it can create wonderful results.

DRYBRUSHING – the method of skimming a small amount of undiluted paint over the surface of the support to leave a broken trail of colour.

EARTH COLOURS – pigments derived originally from coloured earth. These include terre verte, a soft green, and yellow ochre, sienna, umber and Indian red which range in colour from soft yellow to brown.

FUGITIVE – a paint that fades over time or through exposure to light.

GLAZE – paint applied in a transparent or semi-transparent layer to modify the colour underneath. A glaze can intensify or dull down the colour beneath it.

GOLDEN SECTION – the division of a support along geometrical lines to create the 'perfect' proportions. The rule of thirds is a similar, simpler method of positioning the main features.

GOUACHE – an opaque water-based paint which is handled much like watercolour. It is particularly popular with illustrators and graphic designers because of its bright colours and matt finish. Adding plenty of water to the paint makes it more like watercolour, but used neat it has good covering power and unlike watercolour it can be applied to coloured grounds.

GROUND – a prepared painting surface such as a primed canvas. The primer can be tinted in which case the surface is called a 'coloured ground'.

GUM ARABIC – the medium used in watercolour to bind the pigment. Additional gum Arabic can be added to make the paint more transparent and glossy. It needs to be added sparingly and is usually diluted with plenty of water first to ensure it is not overused.

HP PAPER – watercolour paper which is hot pressed to produce a hard, smooth surface. It is ideal for detailed work but the paint has a tendency to run very readily on it. Compare with NOT and Rough paper.

HUE – another word for colour.

MIXED MEDIA – the term used when a painting is worked in a number of different media. Such a painting might be worked in watercolour, gouache, coloured ink and pastel, for example.

NEUTRALS – colours which are hard to describe, often verging on grey or black. These are easily mixed from colours opposite each other on the colour wheel such as blue and orange. What one artist describes as neutral another artist might think is quite vibrant.

NOT PAPER – stands for 'not hot pressed'. Instead the watercolour paper is cold pressed to create a semi-rough finish. This is the most popular paper because it is the most versatile and ideal for both beginners and professionals. Compare with HP paper and Rough paper.

OIL – a painting medium made by combining pigment with oil such as linseed oil or safflower oil. Additional additives such as drier or wax may be used to improve the texture or speed the drying time, for example. Most manufacturers supply two ranges, one aimed at students and the other at professional artists. The students ranges are generally less expensive because they use cheaper pigments and sometimes contain less pigment. It is perfectly acceptable to use paints from both ranges in a painting, if desired.

PAINTING KNIVES – literally knives used for painting. They have shaped blades, some long and thin, others short and wide and almost heart shaped. Their cranked handles help keep hands clear of the paint surface and their pointed ends make a range of marks possible.